MERCHANT SHIPPING

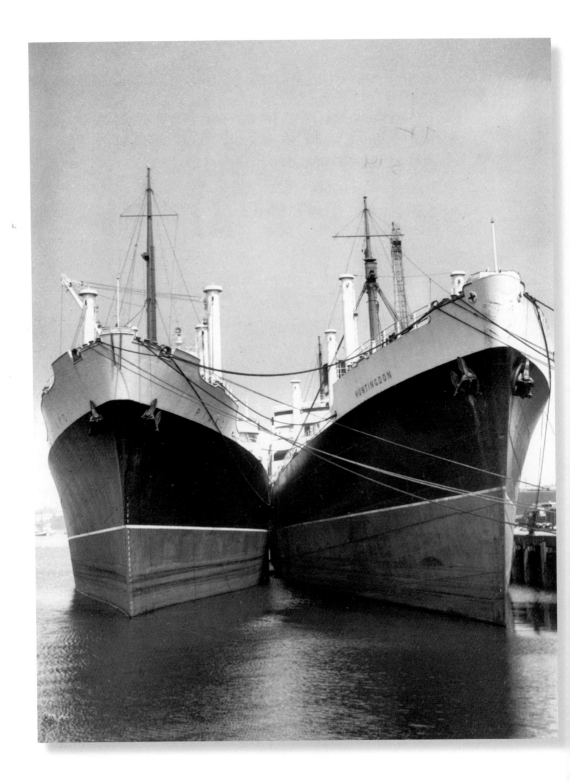

MERCHANT SHIPPING
50 YEARS IN PHOTOGRAPHS

DAVID HUCKNALL

Frontispiece: Moored at County Wharf, Falmouth in July 1963 were Federal S.N. Co.'s *Huntingdon* (1948, 11,281gt) and New Zealand Shipping's *Piako* (1962, 9,986gt). The *Huntingdon*, the second Federal ship to carry the name, was transferred to P&O's General Cargo division in 1973. It was broken up in 1975. The *Piako* went to P&O in 1971 and survived until 1984.

First published 2011

The History Press
The Mill, Brimscombe Port
Stroud, Gloucestershire, GL5 2QG
www.thehistorypress.co.uk

British Library Cataloguing in Publication Data.
A catalogue record for this book is available from the British Library.

ISBN 978 0 7524 5623 2

Typesetting and origination by The History Press
Printed in Great Britain

Contents

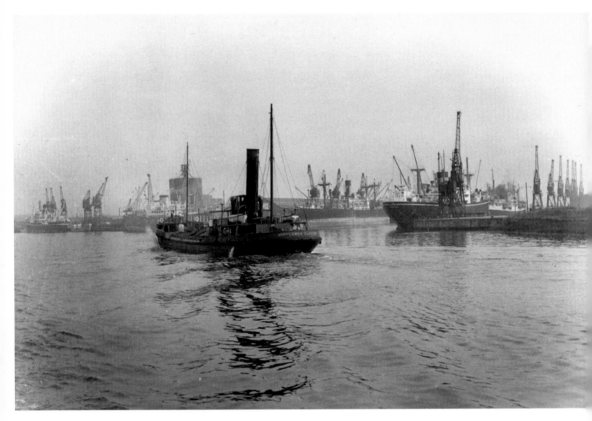

The entrance to King George V Dock lies approximately 4 miles downriver from Glasgow Bridge. Here is the Clyde Navigation Trust's *Hopper No.6* as she moved upriver past the dock entrance. On the right, immediately inside the dock, Johnston Warren Lines' *Mystic* (1959, 6,656gt) on charter to Shaw Savill can be seen, whilst, on the left, an unidentified Blue Funnel ship stands. Both lines were frequent users of the dock. Forward of the starboard bow of the hopper is Shieldhall Wharf, opened in 1958. At the quay can be seen a Brocklebank Line ship. This was most certainly an 'M' class boat with her characteristic funnel and bi-pod masts. Six of these ships were built by Hamilton of Glasgow between 1957 and 1960. (W.A.C. Smith)

Acknowledgements

I should like to thank ABP Southampton who were kind enough to provide me with an annual permit to enter the Eastern and Western Docks at Southampton in the early 2000s. I should also like to thank Brian Errington for printing my negatives so competently.

I am particularly grateful to my wife Susan and my children Rachel and Philip whose holidays over the years have often involved diversions to the nearest port.

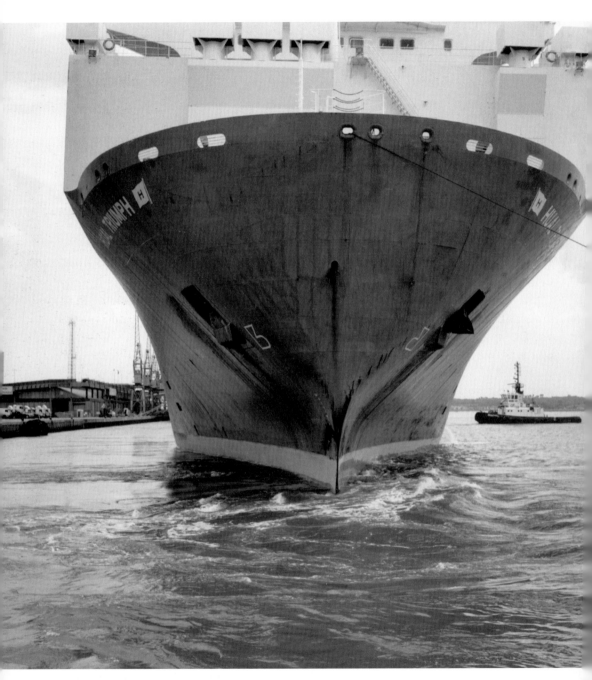

Leaving Berth 41 at Southampton on 23 June 2002 was the *Hual Triumph* (1988, 53,578grt). Höegh-Ugland Auto Liners (HUAL) was a joint venture between Leif Höegh and the Ro-Ro operator and vehicle transporter Ugland.

Introduction

Over the fifty-odd years from the 1960s to the mid-2000s, world shipping has undergone substantial changes reflecting the demands of society and the world economy.

In the 1960s, it was dominated by long-established, mainly European companies, operating fleets of conventional and often elderly cargo ships and relatively small (less than 45,000-ton) tankers. A significant event, however, was the introduction by Sea-Land Inc. of four converted cargo vessels that carried 200x20ft containers each. The service operated from the USA to Rotterdam and Bremen via Grangemouth. Similarly, in the Pacific, Matson used two converted 'jumbo-ised' cargo ships for a container/bulk sugar service between Hawaii and California.

More significantly, Overseas Containers Ltd (OCL), a consortium involving P&O, British and Commonwealth Shipping, Alfred Holt (later Ocean Transport and Trading) and Furness Withy, placed orders for six 27,000gt cellular container ships for the UK–Australia run. The order was for delivery in the first half of 1969. Because containerisation significantly reduced the time a vessel spent in port, a single container ship could do the work of several conventional vessels and led inevitably to fleet redundancy. By 1974, many of the long-established British shipping lines had either reduced their fleets or ceased to exist. UK ports such as Bristol, Glasgow and Manchester were in dire straits and the Port of London was phasing out docks (by 1981, all inner-London docks had been closed, including the Royal Docks).

The 1970s was a period of considerable change. The middle of the decade was marked by the advance of container, Ro-Ro and multipurpose ships. It also showed a huge surge in ship ordering. On 1 April 1970, the world ship order-book stood at around 98 million dwt. By mid-1974, over 200 million dwt were on order. It was a decade of the mammoth ULCC (the 500,000dwt *Batillus* and *Bellamya*) and a time of considerable interest in 'standard' ships such as Austin and Pickersgill's very successful 'Liberty' ship replacement, the SD14. Related designs (Brazil's 'Prinasa' ships) were built under licence to A. and P. Countries such as Poland also began offering standard designs for Ro-Ros and general cargo vessels.

The situation did not last. Precipitated in part by yet another oil crisis, there was a collapse in ship-chartering and eventually in shipbuilding. For example, in 1975 the VLCC *British Resource* (269,695dwt) sailed from the builder's yard in Nagasaki straight to lay-up in Brunei Bay. By the end of the '70s, the order book stood at a mere

25 million tonnes and some yards even entered into loss-making contracts to ensure continuity of employment.

The late 1970s and early '80s marked a depression in most shipping sectors. It was exemplified by the tanker *Burmah Endeavour* (1977, 231,629gt), which was laid up in the Western Docks in Southampton for almost three years from 1983–86. Ocean Transport and Trading's *Tantalus* (1972, 120,787gt) also spent at least two years (1982–84) laid up at Berth 40 in the Eastern Docks. During this period, the UK's merchant fleet shrank by almost 1,000 ships.

The 1980s and '90s saw further changes to the structure of the world's merchant fleet. The total number of ships fell and there was an increased use of flags-of-convenience rather than Western European – or even Japanese – flags. However, larger and more efficient vessels maintained capacity. Versatility was now a key requirement – ships that could carry cars, trucks and containers as well as general cargo began to be demanded. This trend has continued into the 2000s. In an overview of ship types for 2008, the IMO's Maritime Centre gave the following breakdown:

–		gt	Av. age (y)
Container	4,641	139,563,042	10
General Cargo	17,002	56,433,536	24
Ro-Ro Cargo	2,489	41,634,505	17
Refrigerated Cargo	1,210	5,989,059	23

The container-ship fleet now represents 12.9 per cent of the world total. The report also pointed out that the trend in new ships is more and more in favour of specialisation and that the amount of tonnage on order at the end of 2007 stood at the highest level since the beginning of the decade.

The present state of shipping was summarised in this IMO report, when it concluded that: '...ships have never been so technically advanced, never been so sophisticated, never been more immense, never carried so much cargo and never been safer, than they are today.'

This book is a collection of photographs that shows a wide range of merchant ships, covering the years from the mid-1960s to the mid-2000s, in the UK and elsewhere. The sections reflect the ships trading in those decades and, of course, these photographs also reflect my own preferences.

Finally, I am sometimes asked why, coming as I do from the southernmost tip of the West Riding of Yorkshire, I have developed such a liking for ships. Recently, I came across the probable answer whilst watching an interview with the great American railway photographer O. Winston Link. When asked why he had developed his love of trains, he replied without hesitation, 'It's the places they go.'

Leeds City Council

Renewals Tel: 0845 1207271
Enquiries Tel: 0113 2476016

Borrowed Items 26/11/2016 13:54

XXXX4811

Item Title	Due Date
* Merchant shipping : 50 years in photographs	17/12/2016
Computer basics : absolute beginner's guide. Windows 8.1	07/12/2016
Canals of Britain : a comprehensive guide	15/12/2016

* Indicates items borrowed today
Thankyou for using this unit
http://librarycatalogue.leedslearning.net

Chapter 1

1960s

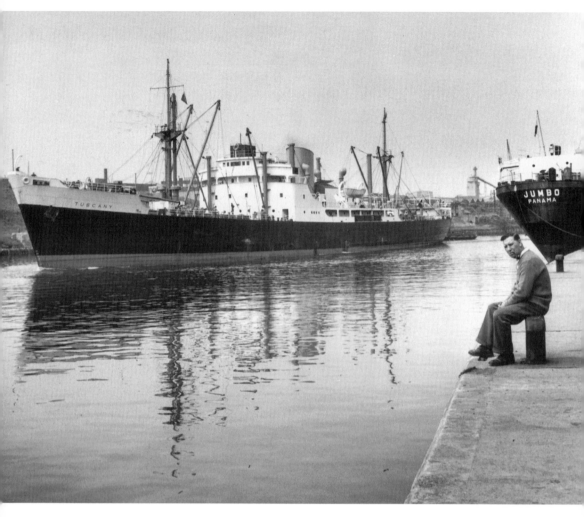

East of the Ouseburn (a tributary of the Tyne) were the Newcastle Corporation Quays where general cargo was dealt with at berths assigned to particular cargoes or routes. Here, probably at Berth 28 in 1966, the Panama-registered trader *Jumbo* was moored. The pipe-smoking observer, sitting on a bollard at Berth 29, appeared to be unaware of the outward-bound Royal Mail Line vessel *Tuscany* (1956, 7,455t).

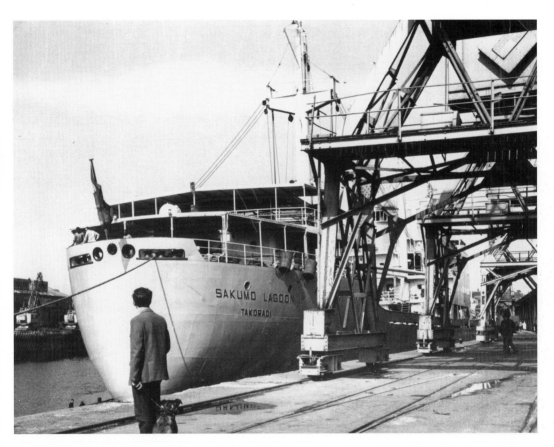

Ready to sail, Black Star Lines' *Sakumo Lagoon* (1964, 7,446gt) was moored, possibly at Berth 25 or 26 in 1966, awaiting the Ridley tug *Maximus*. She had been built at Swan Hunter and Whigham Richardson's Wallsend yard.

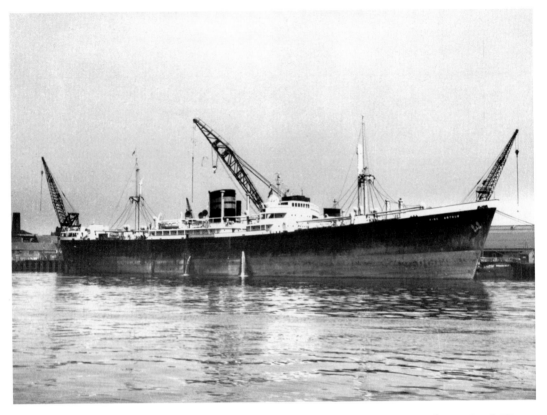

Moored at South Shields, close to the facilities of Middle Docks & Engineering Co. Ltd, King Line's *King Arthur* (1953, 5,900t) was seen in October 1969. Transferred to Clan Line Steamers in 1959, she reverted to King Line's service in 1963. In 1972, she was sold by Houston Line to Cyprus and, after several owners and names, she was scrapped at Chittagong in 1983.

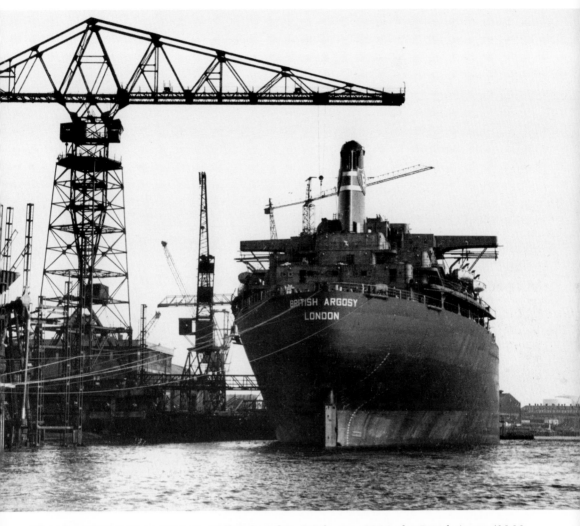

When launched at Swan Hunter's Wallsend yard on 7 February 1966, the *British Argosy* (1966, 112,786gt) was the largest ship to be built in the North East of England. At the time, Swan Hunters, together with Vickers, were two of the four large shipbuilders that occupied this part of the mid-tidal Tyne. Thousands of workers were employed by them but, as Blue Funnel Line discovered to its cost during the building of the *Priam* class, the yards had severe worker-management problems.

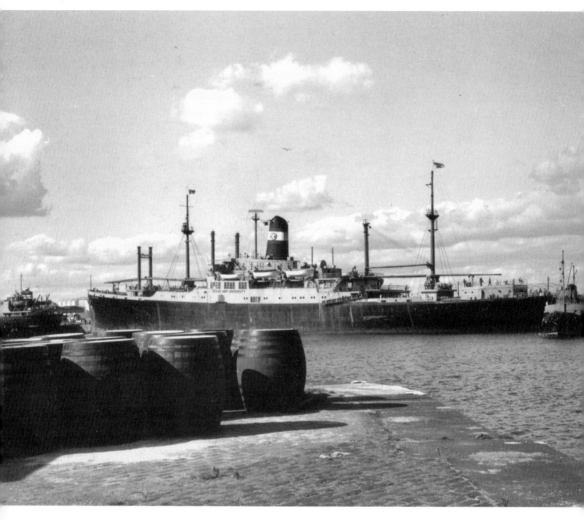

Built in 1944 at Sparrow's Point, Maryland, by the Bethlehem Steel Corporation and launched as the *USS Queens*, the *Texas Clipper* had a long and distinguished career. Until 1948, she carried the name *USS Excambion* and, from 1948–58, she was one of the 'Four Aces' of American Export Lines. In 1965, the Federal Government lent the *Excambion* to the Texas Maritime Academy/Texas A & M University at Galveston and for the next twenty-one years she was a maritime training establishment. In June 1965, the *Texas Clipper* undertook her maiden voyage to Northern Europe and, as part of this, visited Leith. She is seen here in the basin leading to the lock to Imperial Dock, Leith. The *Texas Clipper* completed her final duties on 4 August 1994.

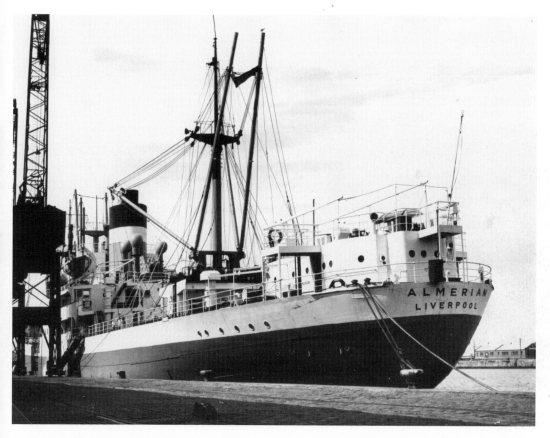

Ellerman-Papayanni Lines' *Almerian* was the second vessel to bear the name. Built in 1956 at Caledon, Dundee, she became the *City of Leeds* in 1962, reverting to *Almerian* in 1964. Here, on 15 May 1965, she is seen on the south-east side of Edinburgh Dock, Leith, having brought a cargo of potatoes from Egypt.

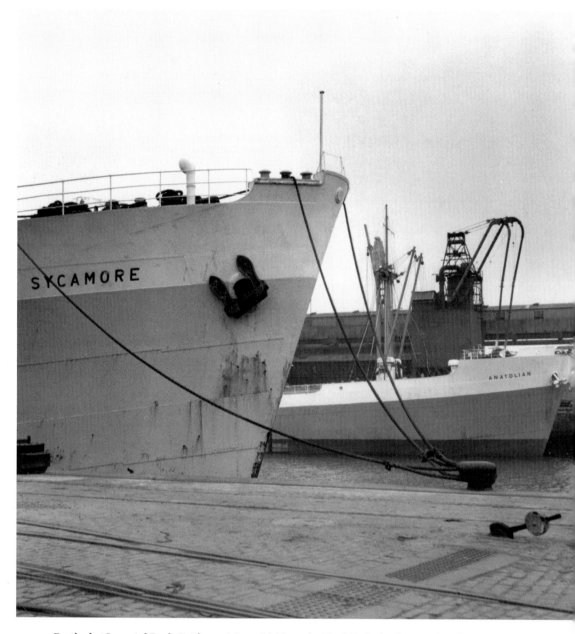

Berthed at Imperial Dock, Leith, on 9 June 1965 on the No.5/6 shed-side, was the Ellerman-Papayanni Mediterranean trader *Anatolian* (1955, 3,799gt). Across the dock (No.7 Shed) was Johnson Warren Lines' *Sycamore* (1954, 3,600t). In the summers of 1966 and 1968, the *Anatolian* was chartered to the Cunard Steamship Co. as the *Ascania*. She was eventually broken up in 1978.

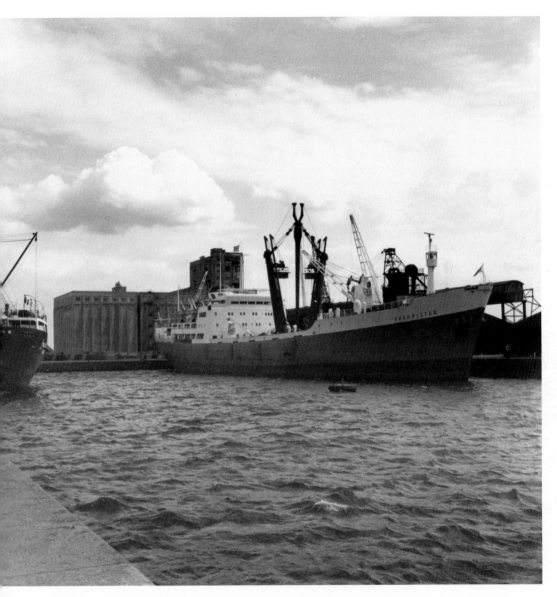

The *Shahristan* (1965, 9,280gt) was built by J. Redhead & Sons Ltd, South Shields, for the Shahristan Steamship Co. (Strick Line) and launched in January 1965. She is seen here at Imperial Dock on 19 April 1965 on what may have been the return leg of her maiden voyage. On 1 May 1972, she was transferred to P&O (General Cargo Division). In October 1979, after a few more years of service, she arrived at Chittagong for scrapping.

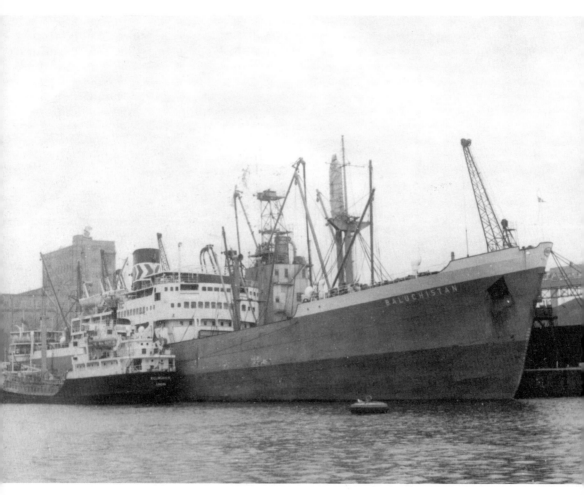

Strick Line's *Baluchistan* (1956, 8,370t) was built by J. Redhead & Sons Ltd, South Shields. She was launched in December 1955 and completed in May 1956. She is seen here on 28 May 1969 at Imperial Dock, Leith, being refuelled by Shell's tanker *Killingholme*. Transferred to P&O's General Cargo division on 1 May 1972, she was scrapped at Kaohsiung in August 1977.

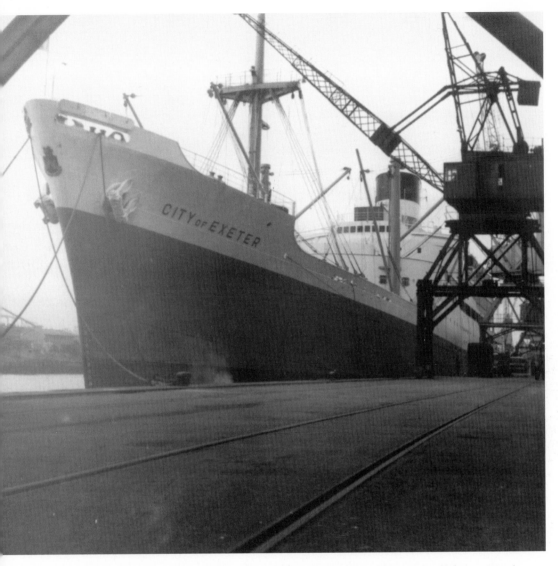

Ellerman & Bucknall's ships called regularly at Newcastle upon Tyne, possibly as part of the company's London to South and East Africa run. Seen here at Newcastle Quays in 1966 is the *City of Exeter* (1952, 13,363gt). In 1972, the *City of Exeter* was converted to a passenger/car carrier and worked between Patras and Ancona. She was eventually broken up in Turkey in 1998.

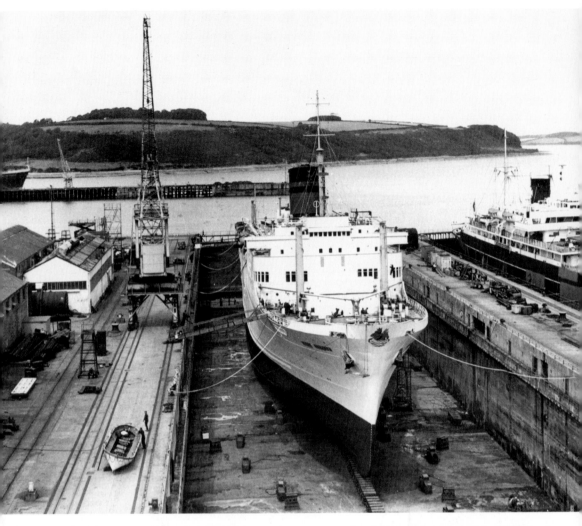

Furness Withy's *Ocean Monarch* (1951, 13,654grt) was in dry dock at Falmouth in July 1963. In the adjacent No.1 Dock was Houlder Line's *Hornby Grange* (1946, 10,365t), a chilled-meat carrier used on Houlder's services to and from South America from 1946 to 1969. In 1966, after fifteen years of regular cruising between New York and Bermuda, the *Ocean Monarch* was laid up. Subsequently, in 1981, after a few years each with Bulgarian and Greek shipowners, she was destroyed by fire.

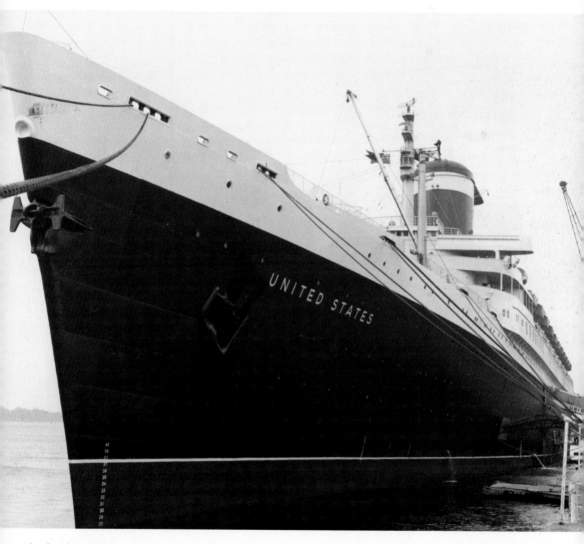

The flagship of the United States Line in the 1950s, the SS *United States* (1952, 53,330gt) could carry 1,928 passengers and had a crew of 900. She broke the speed record for the Atlantic Crossing on her maiden voyage and continues to hold the Blue Riband. The *United States* is seen here at Ocean Terminal at Southampton. She was purchased in 2003 by Norwegian Cruise Line; in 2009, NCL offered her up for sale. (George Harrison)

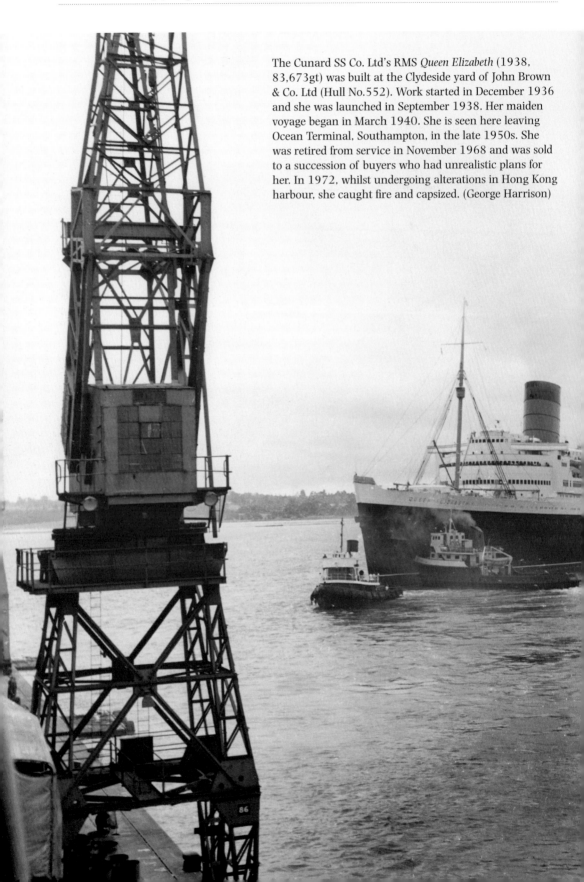

The Cunard SS Co. Ltd's RMS *Queen Elizabeth* (1938, 83,673gt) was built at the Clydeside yard of John Brown & Co. Ltd (Hull No.552). Work started in December 1936 and she was launched in September 1938. Her maiden voyage began in March 1940. She is seen here leaving Ocean Terminal, Southampton, in the late 1950s. She was retired from service in November 1968 and was sold to a succession of buyers who had unrealistic plans for her. In 1972, whilst undergoing alterations in Hong Kong harbour, she caught fire and capsized. (George Harrison)

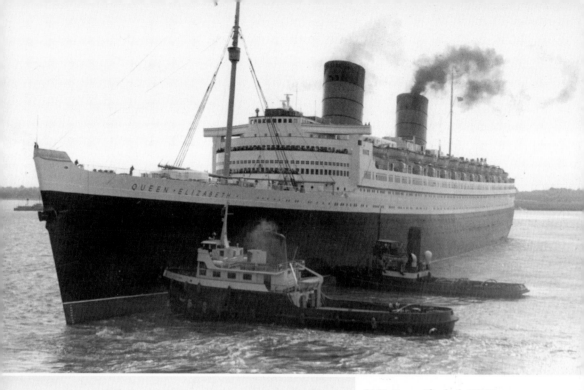

RMS *Queen Elizabeth* (1938, 83,673gt) is seen leaving Ocean Terminal on her regular New York-bound sailing. Together with the *Queen Mary*, she dominated the transatlantic passenger trade until travel by air began to become predominant. She was retired from service in 1968. (Alex Merison)

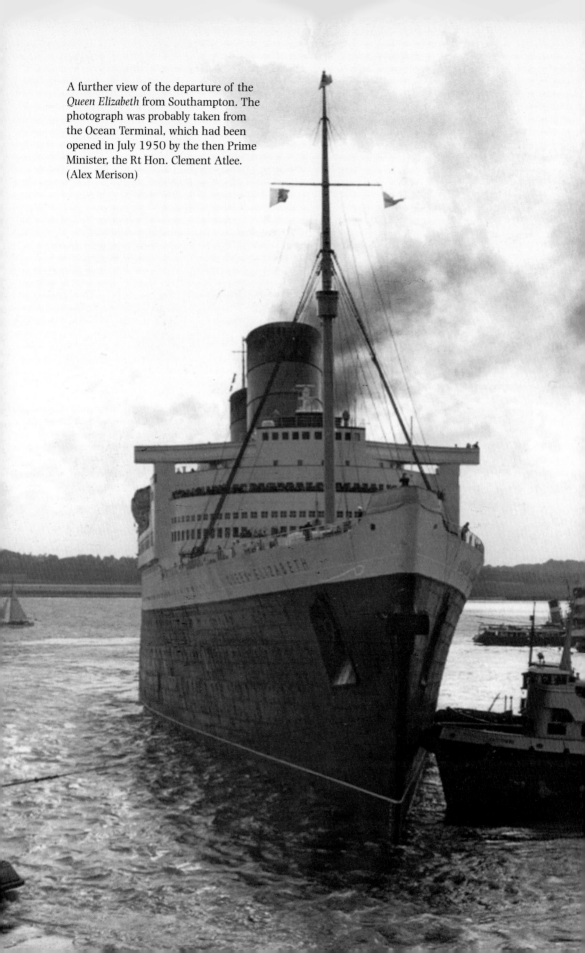

A further view of the departure of the *Queen Elizabeth* from Southampton. The photograph was probably taken from the Ocean Terminal, which had been opened in July 1950 by the then Prime Minister, the Rt Hon. Clement Atlee. (Alex Merison)

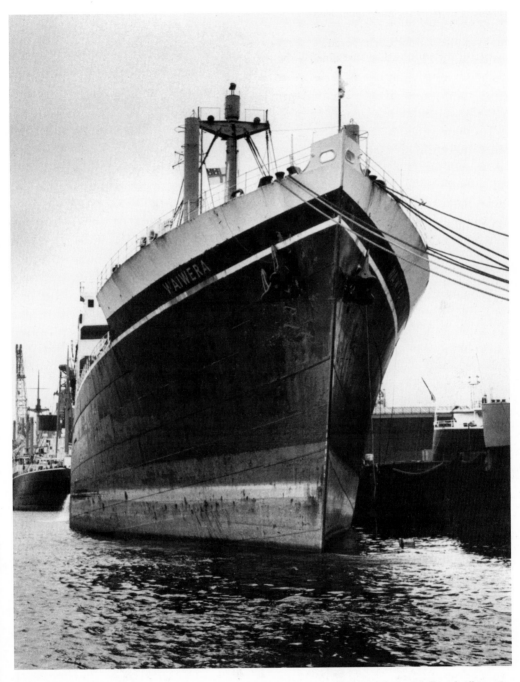

The *Waiwera* (1944, 12,028grt) was the third ship to carry the name for Shaw, Savill and Albion Co. She is seen awaiting a dry dock at North Shields in May 1966. Built by Harland & Wolff in Belfast, she was a twin-screw vessel with a speed of 16kt and one of the ships that maintained a regular service between London and New Zealand's ports. In 1967 she was sold to a Greek company for her final voyage to Kaohsiung for breaking.

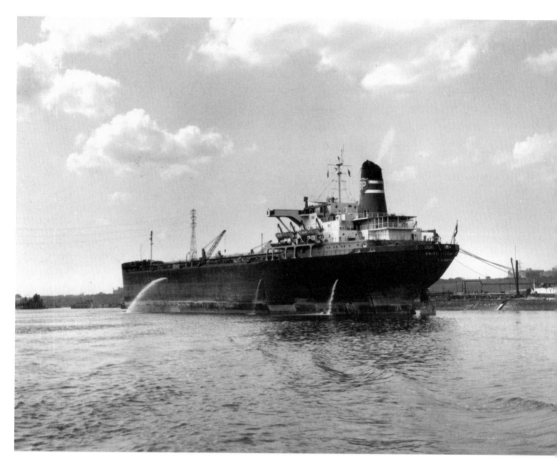

On the opposite side of the Jarrow Slake on the mid-tidal Tyne was the old Northumberland Dock, which had been partially filled-in. The coal-shipping staiths had been removed and an oil-import discharge facility had been installed. There was also a tanker-cleaning berth and here BP Tanker Co. Ltd's *British Commerce* (1965, 68,77dwt) was being dealt with in May 1966.

The CEGB (Central Electricity Generating Board) owned several colliers that carried coal from mining areas to coal-fired power stations, usually located on the Thames. Seen here at the coal hoist on the north-east side of Edinburgh Dock, Leith, in the spring of 1965 is the *Captain J.M. Donaldson* (1950, 3,400t). Built by Pickersgill in Sunderland, she was a single-screw vessel with a speed of 10.5 knots.

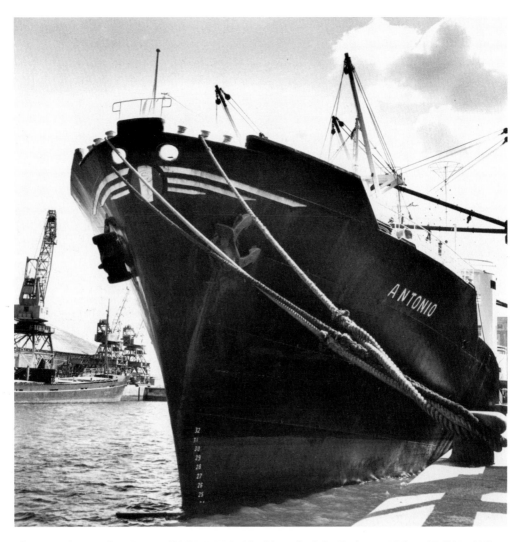

The general cargo ship *Antonio* (1957, 8,832gt) had been built by Kockums, Malmo (Hull No.415) as the *Bellully*. She is seen here at Imperial Dock, Leith, in the spring of 1965. Although painted out, the Christen Smith logo can still be seen. Over her career, the vessel underwent several renamings (*Bellully*, *Antonio*, *Camingoy*, *Lendas*, *Omalos*). In 1978, she stranded off Chios. She was re-floated and laid up. She was eventually scrapped at Megara in 1983.

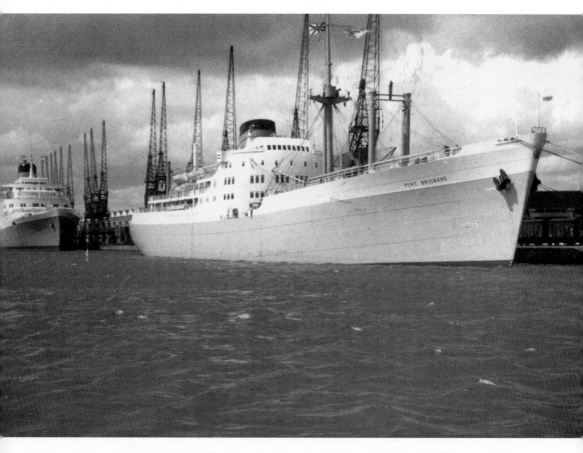

Port Line's *Port Brisbane* (1949, 11,942gt) was built by Swan Hunter and Whigham Richardson (Yard No.1763). She is seen here at 101 Berth at Southampton with a Union Castle mail ship at 102 Berth. Port Line was started in 1949 as the Commonwealth and Dominion Line Ltd with its main trading route as the UK to Australia and New Zealand. (George Harrison)

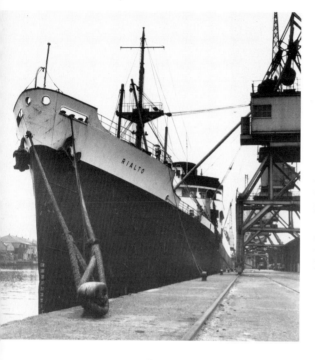

Left: Several cargo lines had berths at the Corporation quays in Newcastle upon Tyne. Deep-sea, general cargo vessels to the Atlantic ports of Canada and the USA tended to berth (nos 22-29) east of the Ouseburn and were served by eighteen electric cranes. Here, Ellerman's Wilson Line ship *Rialto* (1949, 5,000t) is shown loading cargo, probably at Berth No.25, for the Great Lakes ports and Detroit in 1966.

Below: The former British India Line troopship *Nevasa* had been built by Barclay, Curle & Co., Glasgow (Yard No.733). She entered service in 1956 and was used as a troopship until 1962. From 1964 until 1974, she acted as an educational cruise ship. Seen here, she was undergoing some refurbishment in dry dock at Falmouth on a drizzly day in July 1965.

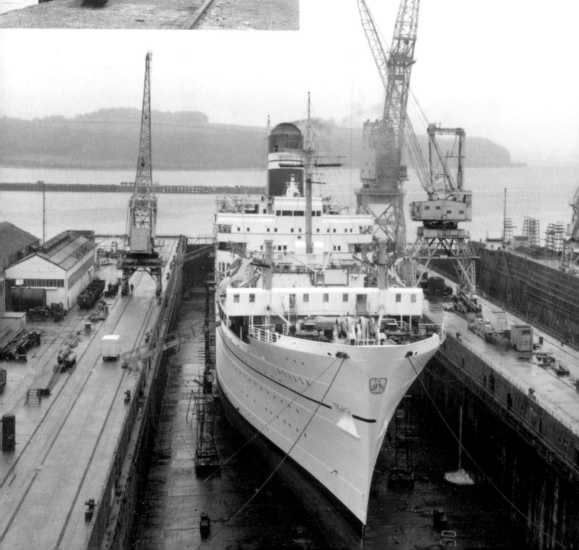

Chapter 2

1970s

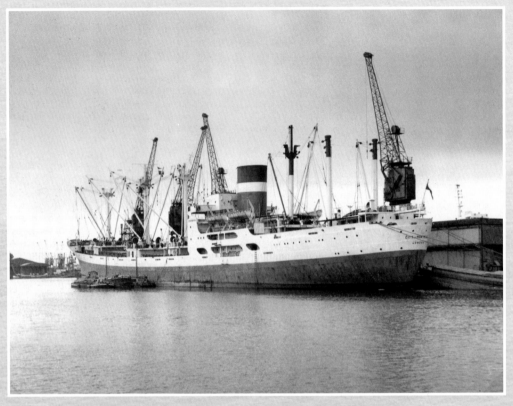

Ellerman and Bucknall's *City of Montreal* (1960, 10,551gt) was built by Barclay, Curle & Co., Glasgow, and launched as the *City of Sydney*. Containerisation of the Australian trade brought about her transfer to Canadian services in 1971. She is seen here at Queen Elizabeth Dock, Hull, on 17 August 1975. She was sold to Hong Kong in 1977 and renamed *Yat Fei*.

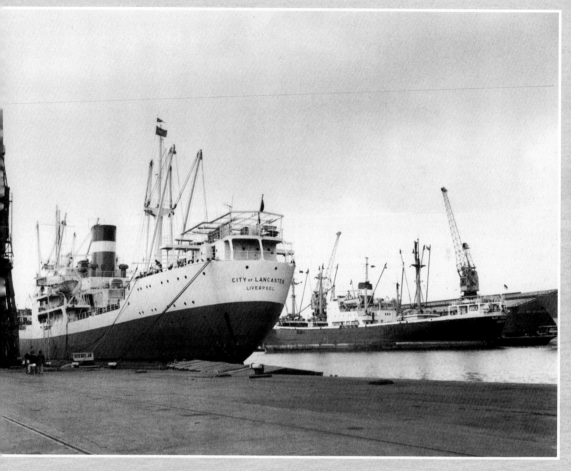

Ellerman's *City of Lancaster* (1958, 4,949gt) was at No.12 Quay of King George on 17 August 1975. Across the dock at 9 Shed on the North Quay was Djakarta Lloyd's *Djatibarang* (1960, 9,736gt).

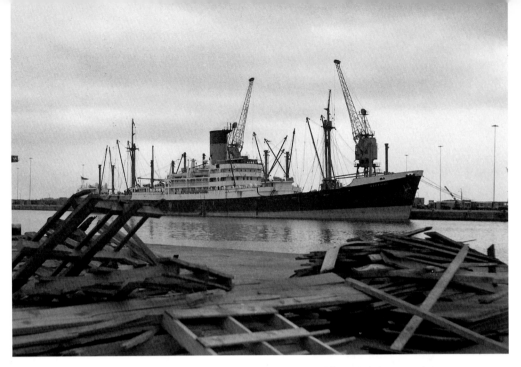

Above: Owned by China Mutual Steam Navigation Ltd (Blue Funnel), the *Ascanius* (1950, 7,692gt) was built by Harland & Wolff, Belfast. She is seen here at Queen Elizabeth Dock, Hull, on 17 August 1975. Notable, and clearly visible, is her bent fore-topmast which she carried for at least three years. In 1976, she was sold to Saudi Arabian shipowners and renamed *Mastura*. With this name, she was broken up by Hughes Bolckow at Blyth.

Below: The general cargo ship *Pioneer Contender* (1963; 11,164gt; IMO 5410119) entered service with United States Line as the *American Contender*. Built by the Bethlehem Steel Co. at Quincy, Maine, she saw service in the Vietnam War and was 'decorated' with MARAD's 'gallant ship' award after involvement in the rescue of 4,000 refugees from Danang. She is seen here at Rotterdam on 13 July 1975. Laid up from 1981–88, she was then sold for scrapping.

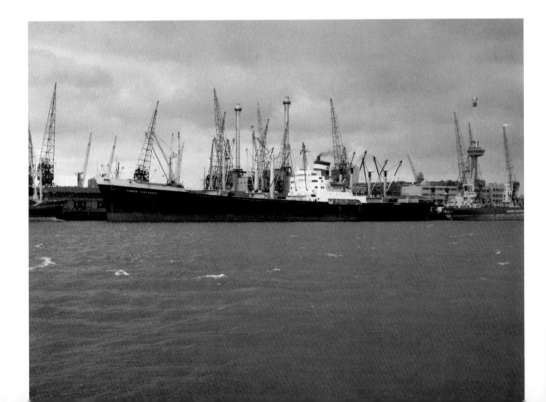

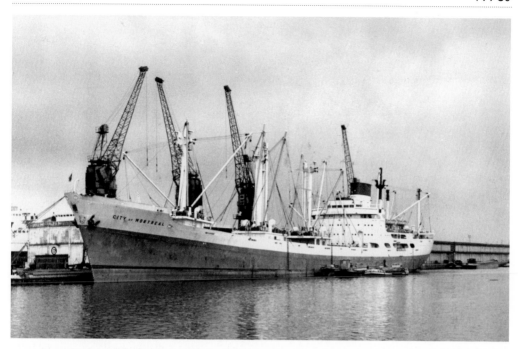

A view of the *City of Montreal* (1960, 10,551gt) at Queen Elizabeth Dock, Hull. Alongside the vessel are a group of barges. It had been a custom at Hull not to charge tonnage dues on lighters and river craft and these were allowed to enter the first dock free of charge. Subsequent Hull Dock Acts implied that no wharfage payments could be levied on goods discharged or loaded overside to or from lighters or river craft.

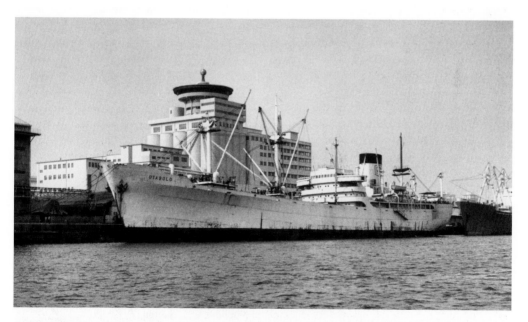

At Keppel Docks, Singapore, on 10 March 1979, was the Singaporean vessel *Otagold* (1959, 9,914gt). Built by Alexander Stephen & Sons Ltd as the *City of Melbourne* for Ellerman and Bucknall's Australian trade, she was switched to its South African Services as the *City of Cape Town*. She became the *Otagold* towards the end of 1978 and was broken up in 1979.

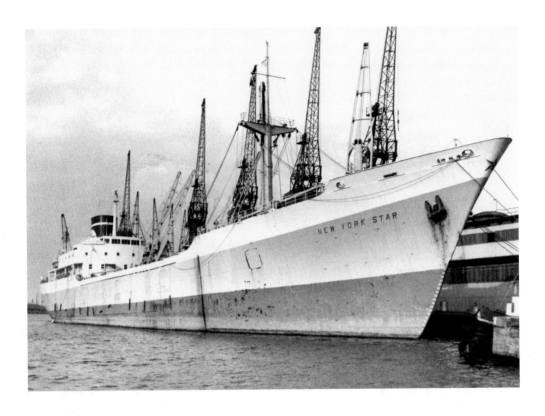

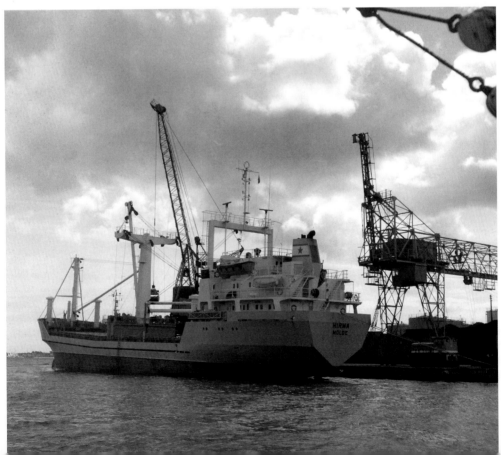

On 30 December 1979, Bank Line's *Clydebank* (1974, 11,405grt) was moored at No.8 Shed of King George Dock at Hull. For many years, Andrew Weir & Co. Ltd (Bank Line's owners) pursued a policy of fleet replacement from British shipyards. *Clydebank* was a product of Swan Hunter.

Opposite above: The *New York Star* (1965, 7,887gt) was built by Bartram & Sons Ltd, Sunderland (Yard No.405). In 1973, she was lengthened by Framnaes Vaerksted A/S, Sandefjord, increasing her gross weight to 9,267t. She is seen here at transit shed 'O' in the Royal Edward Dock, Avonmouth, on 1 October 1978.

Opposite below: Seen at Poole on 26 May 1979 was the Norwegian vessel *Hirma*, registered in Molde. At the time, Poole Quay and its immediate environs handled a wide range of cargoes, including coal for Poole power station, grain and timber. Over the years, shipping activity has moved to reclaimed land on the Hamworthy side of the quay.

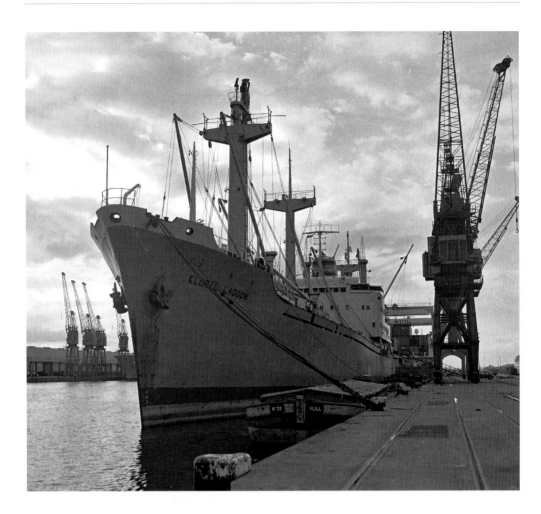

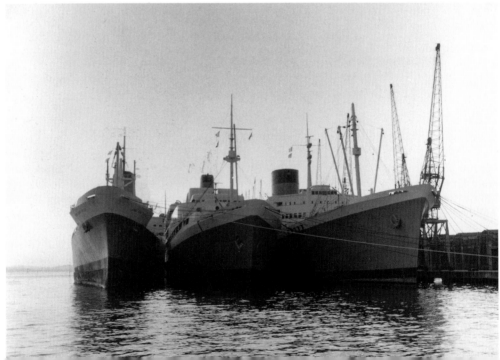

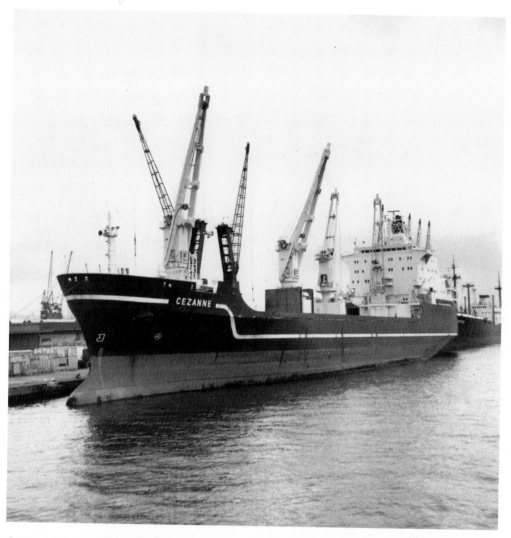

Compagnie Generale Maritime's *Cezanne* (1977, 13,923gt) was at Le Havre on 1 September 1978. In 1983, she was sold to Nouvelle Compagnie Havraise Peninsulaire and renamed *Ile Maurice*.

Opposite above: With a cluster of lighters and barges, Black Star Lines' *Klorte Lagoon* (1965, 7,155gt) was alongside, probably at the North Quay of King George Dock, Hull on 23 September 1979.

Opposite below: In the mid-1970s, Berth 102 was used to moor out-of-use Union Castle ships. Seen here are *Edinburgh Castle* (1948, 27,489gt) at the quayside, *Good Hope Castle* (1965, 10,538gt), outermost, and between, the *Reina del Mar* (1956, 20,747gt).

At No.4 Berth, Royal Victoria Dock, London, on 31 March 1974, were Blue Star Line's *Buenos Aires Star* (1956, 8,267gt) and Royal Mail Line's *Drina* (1953, 10,961grt).

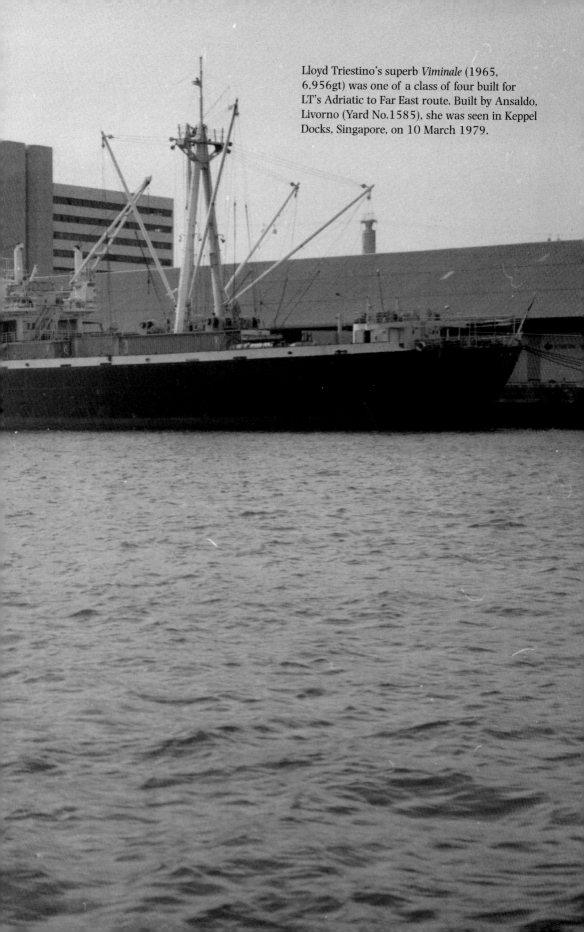

Lloyd Triestino's superb *Viminale* (1965, 6,956gt) was one of a class of four built for LT's Adriatic to Far East route. Built by Ansaldo, Livorno (Yard No.1585), she was seen in Keppel Docks, Singapore, on 10 March 1979.

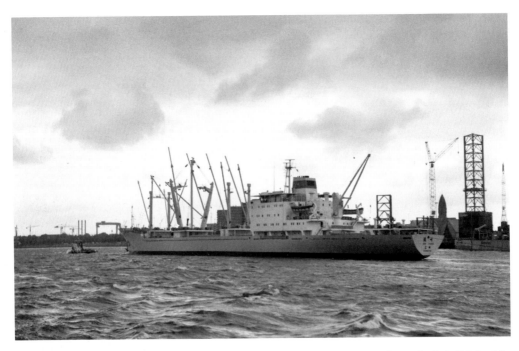

The Chinese cargo ship *Han Chuan* (1974, 7,500/10,744gt; IMO 7334230) was built in Rijeka (the former Yugoslavia). She was one of four identical ships, the others being the *Jiang Chuan*, the *Yin Chuan* and the *Yong Chuan*. Here she was leaving Rotterdam on 13 July 1975.

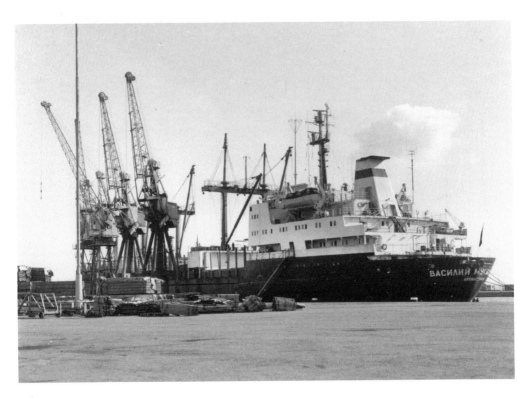

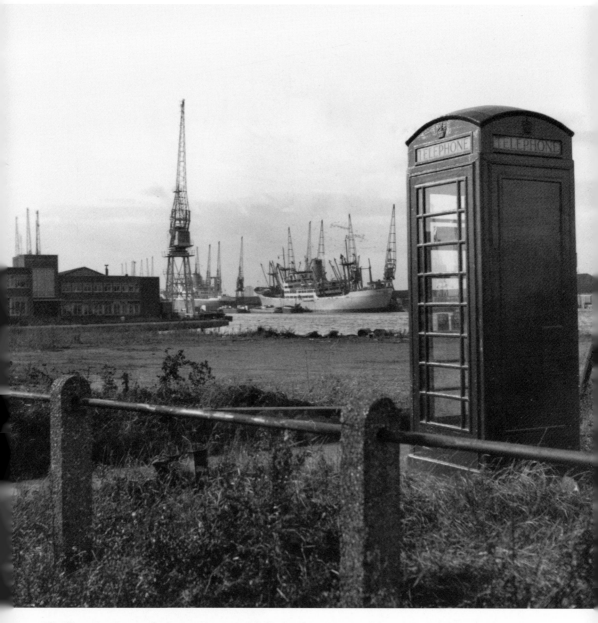

Off Albert Road, near dock Gate 16, some of the berths in Royal Albert Dock, London, could be seen. On 22 September 1973, Ben Line's *Benlomond* (1957, 10,300gt) was moored close to Shed 9 being loaded for the outward leg of her trip to the Far East.

Opposite below: In the 1960s, cargoes of sawn softwoods were second on the list of the fifteen most valuable foreign trade imports into Hull. The Polish-built type B540 *Vasiliy Musinskiy* (1973, 10,200gt) was seen at the port on 29 September 1979 with stocks of sawn timber on the quayside.

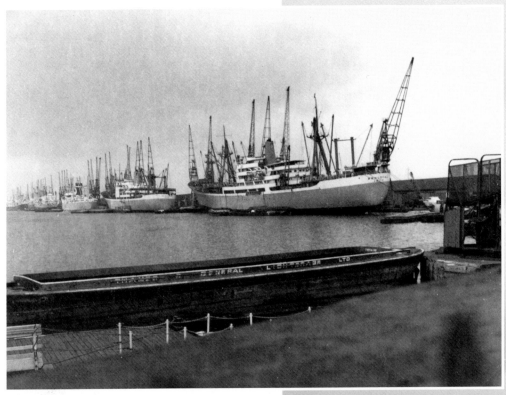

From Woolwich Manor Way (a continuation of Albert Road) on the afternoon of 23 October 1971, some of the vessels that could be seen in Royal Albert Dock were, from left to right, Blue Star's *Canterbury Star* (1960, 7,437gt), Ben Line Steamers' *Bengloe* (1961, 10,955gt) and *Benloyal* (1959, 10,929t).

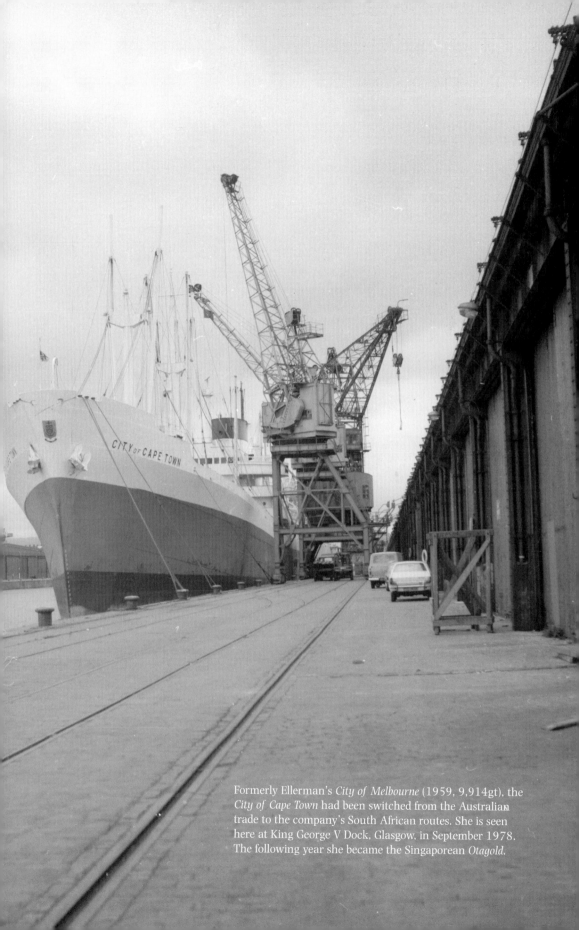

Formerly Ellerman's *City of Melbourne* (1959, 9,914gt), the
City of Cape Town had been switched from the Australian
trade to the company's South African routes. She is seen
here at King George V Dock, Glasgow, in September 1978.
The following year she became the Singaporean *Otagold*.

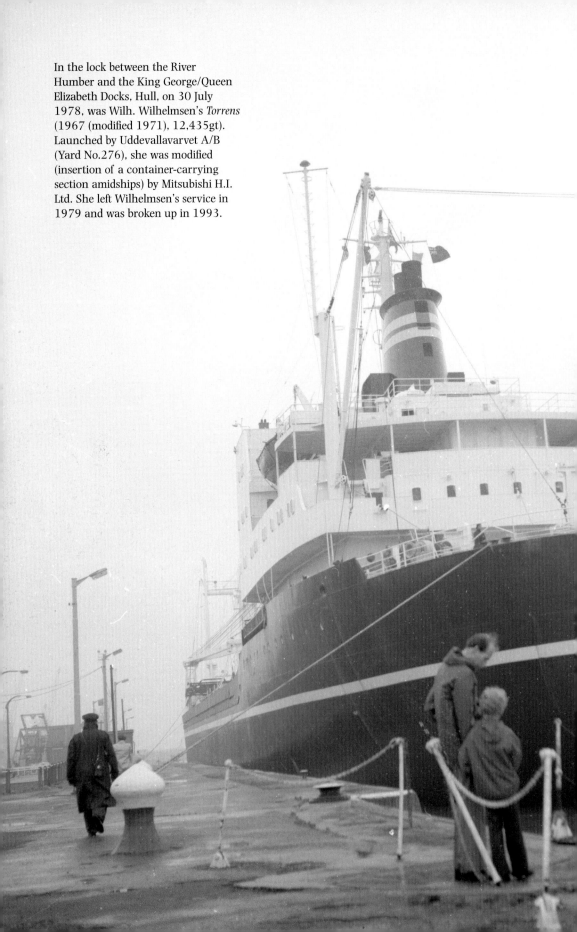

In the lock between the River Humber and the King George/Queen Elizabeth Docks, Hull, on 30 July 1978, was Wilh. Wilhelmsen's *Torrens* (1967 (modified 1971), 12,435gt). Launched by Uddevallavarvet A/B (Yard No.276), she was modified (insertion of a container-carrying section amidships) by Mitsubishi H.I. Ltd. She left Wilhelmsen's service in 1979 and was broken up in 1993.

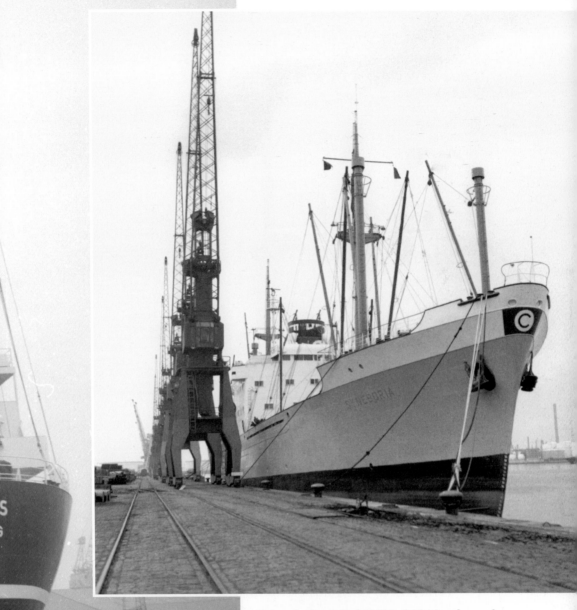

Formerly *Straat Cook* (1956, 5,234t) and owned by Royal Interocean Lines, the *Syneboria* was at Antwerp on 21 April 1978. The *Straat Cook* had been sold in 1974 to Jupiter Lines, Durban, and renamed *Jupiter Sun*. Two years later she became the Greek-owned *Syneboria*.

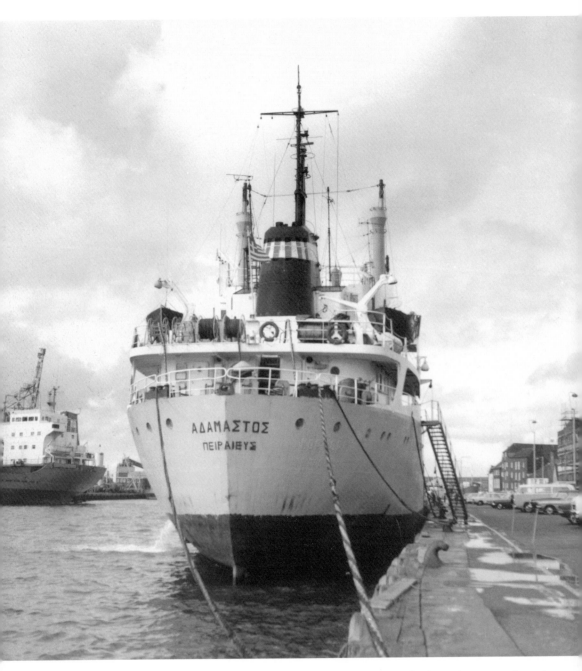

Temporarily moored at Poole Quay on 12 October 1979, and waiting to discharge her cargo of pumice from Santorini, was the Greek *Adamastos* (1963, 900gt), formerly the East German *Kormoran*. Moored across from the *Adamastos* was Denholm's *Mishnish*.

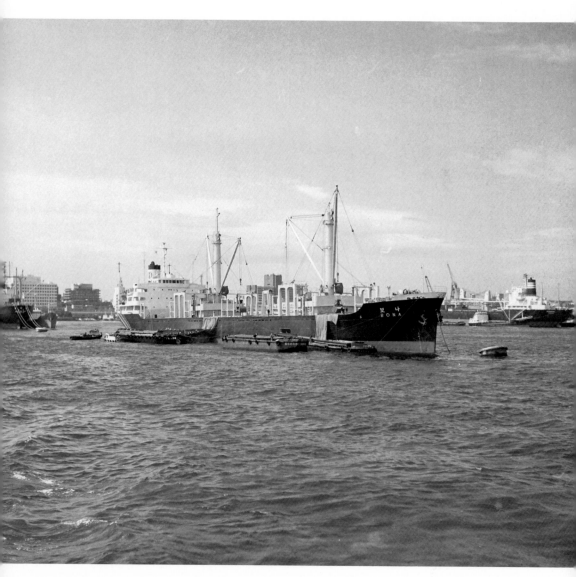

Unloading logs into barges at Yokohama, on the morning of 17 March 1979, was the Panamanian-registered *Bona*.

The Brazilian ship *Frotakobe* (1978, 11,372grt) was at Yokohama
on 17 March 1979. She was one of thirteen PR 121 'Prinasa' ships
ordered from Maua Shipyard, Niteroi. She was scrapped in 1986
after a fire damaged her engine room.

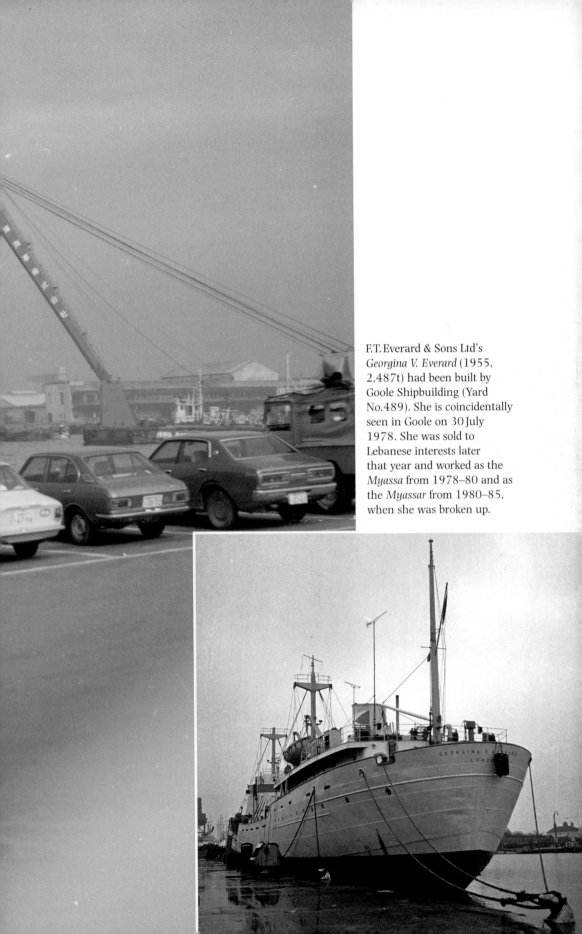

F.T. Everard & Sons Ltd's *Georgina V. Everard* (1955, 2,487t) had been built by Goole Shipbuilding (Yard No.489). She is coincidentally seen in Goole on 30 July 1978. She was sold to Lebanese interests later that year and worked as the *Myassa* from 1978–80 and as the *Myassar* from 1980–85, when she was broken up.

Seen at Poole in the late 1970s, Silloth Shipping Co. Ltd's *Silloth Stag* (1975, 800grt) was managed by Gillie & Blair Ltd, Newcastle. Built by Beverley Shipbuilders, she appears to be trading still.

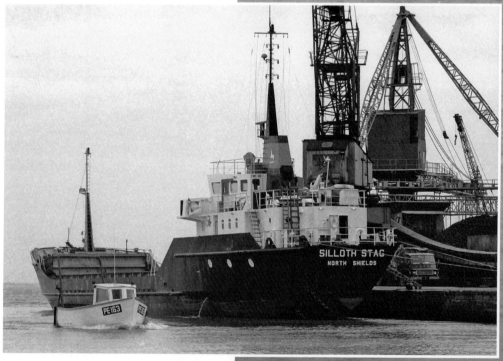

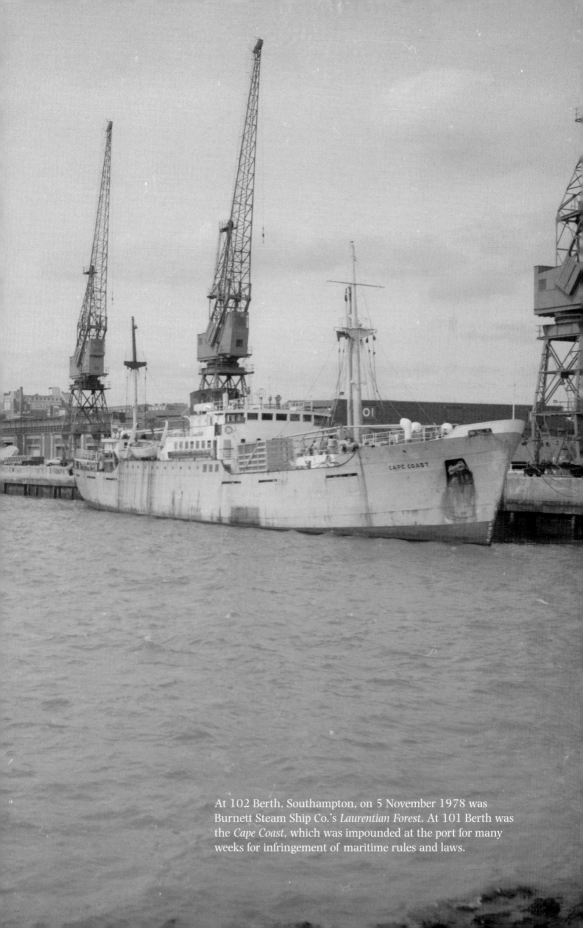

At 102 Berth, Southampton, on 5 November 1978 was
Burnett Steam Ship Co.'s *Laurentian Forest*. At 101 Berth was
the *Cape Coast*, which was impounded at the port for many
weeks for infringement of maritime rules and laws.

Seen at Gunness Wharf in 1978, Turnbull and Scott's *Flowergate* (1976, 1,598t) had been built by Scheeps. Gebr. Van Diepen NV, Waterhuizen. She was sold in 1982 and renamed *Gate Flower*; she has had four subsequent name changes and since 2006 has traded as *Al Karim*.

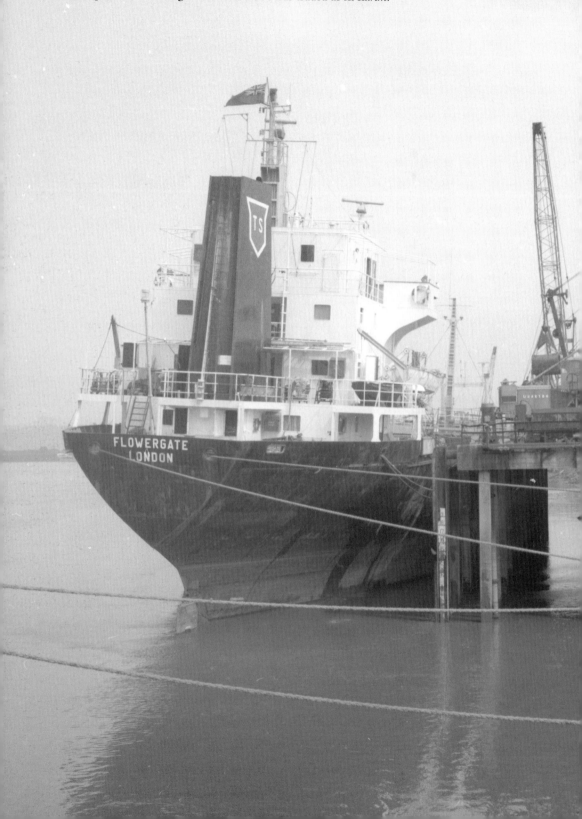

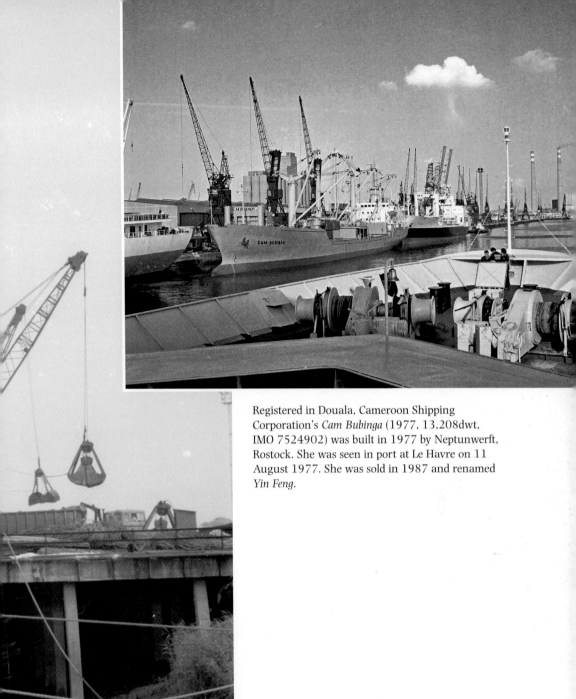

Registered in Douala, Cameroon Shipping Corporation's *Cam Bubinga* (1977, 13,208dwt, IMO 7524902) was built in 1977 by Neptunwerft, Rostock. She was seen in port at Le Havre on 11 August 1977. She was sold in 1987 and renamed *Yin Feng*.

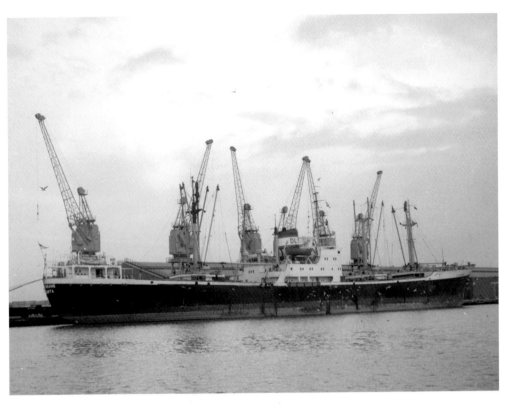

In the King George/Queen Elizabeth Dock, Hull, on 30 December 1979 was the Djakarta Lloyd vessel *Djatibarang* (1960, 9,736gt). She had been built by Rheinstahl Noordseewerke in Emden.

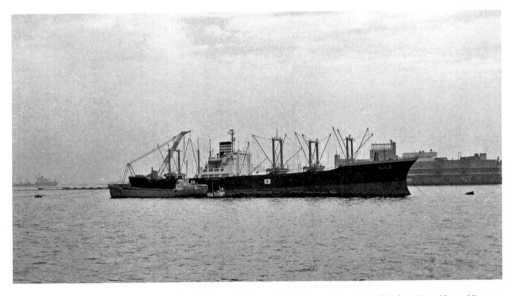

A good natural harbour, the port of Yokohama is located in the north-west of Tokyo Bay. Here, Nippon Yusen Kaisha (NYK)'s *Iwashiro Maru* (1966, 10,460gt) is seen at the port on 17 March 1979.

Chapter 3

1980s

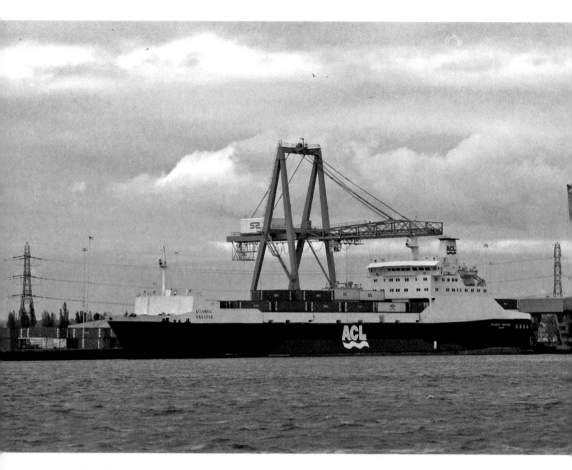

ACL (Atlantic Container Line) was founded by Olaf Wallenius and Swedish America Line. So that a weekly service to Montreal could be offered, two of Stena Lines' Ro-Ro ships were time-chartered. The *Stena Prosper* (1978; IMO 7528609) became the *Atlantic Prosper*. She is shown here at Berth 201, Southampton on 11 May 1980. Regrettably, on 1 November 2006, as the *Finnbirch*, she foundered off the east coast of Sweden in a violent storm.

Opposite above: Salén Reefer Services introduced the 'Winter' series of six 14,800dwt vessels in 1979. The *Winter Wave* was built by Gotaverken Orasundvarvet AB, Landskrona and entered service in the first half of 1979. She was seen entering Le Havre on 17 September 1988.

Opposite below: A further view of the then Singapore-registered reefer *Winter Wave* as she entered the port of Le Havre on 17 September 1988.

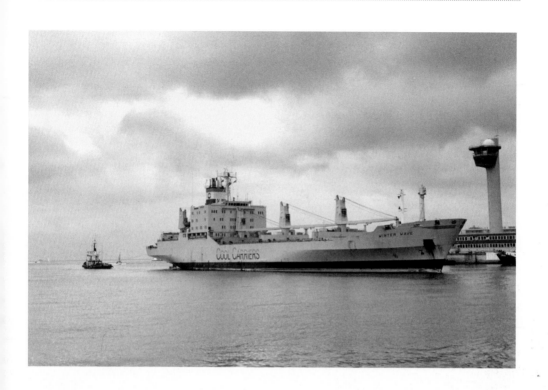

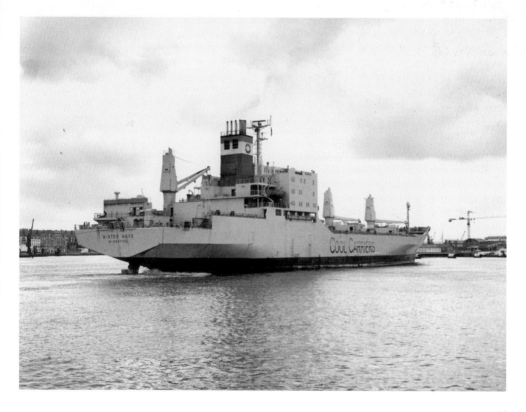

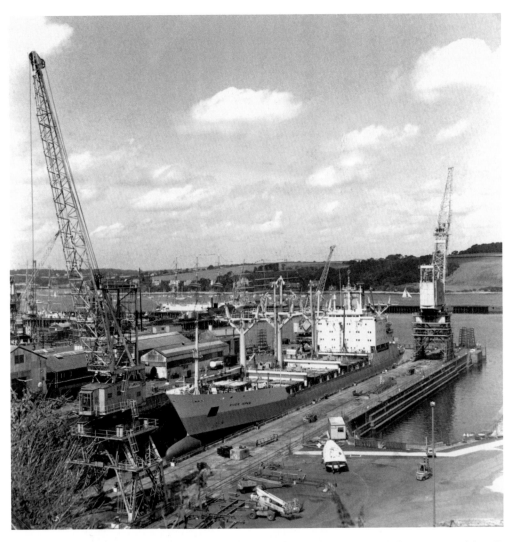

Shown in dry dock at Falmouth in August 1989 was the Nigerian National Shipping Lines' (NNSL Ltd) *River Ikpan* (1980, 12,000grt). By 1995, *all* Nigeria's merchant ships had been either scrapped or shipwrecked. In 2005, the Nigerian Government put the NNSL (by then named the Nigerian Unity Line) up for sale. It had a shipping license but no ships.

Opposite above: The Elder Dempster/Blue Funnel vessel *Lycaon* (1976, 11,804grt) was at Antwerp on 19 October 1980. Built at the Kherson Shipyard in the USSR because British yards could not meet Blue Funnel's urgent demand for extra container capacity, she carried 680 TEUs. During 1980 she was chartered for work between Europe and West Africa.

Opposite below: Dart Continent (1979, 18,663grt) was leaving Southampton in August 1982. Originally the *Seatrain Yorktown*, she became the *Seapac Yorktown* in 1981, and the *Dart Continent* in 1982. Above the stern of the container ship, Blue Funnel's laid-up vessel *Tantalus* (1972, 120,887grt) can be seen in Ocean Dock.

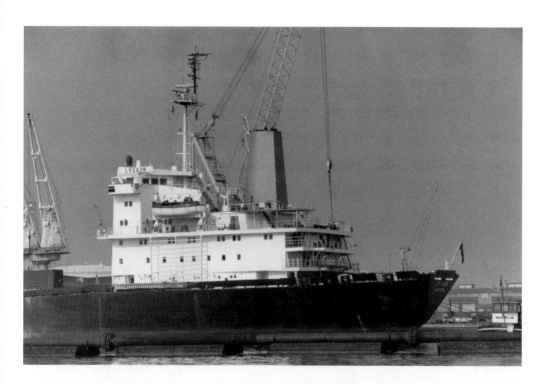

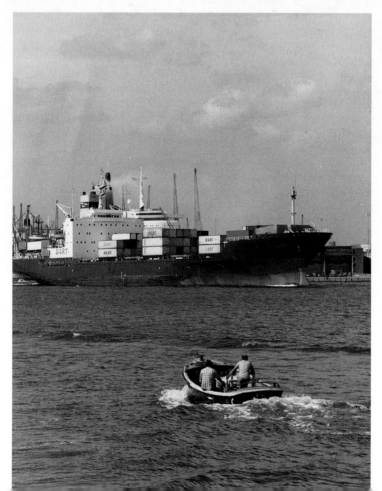

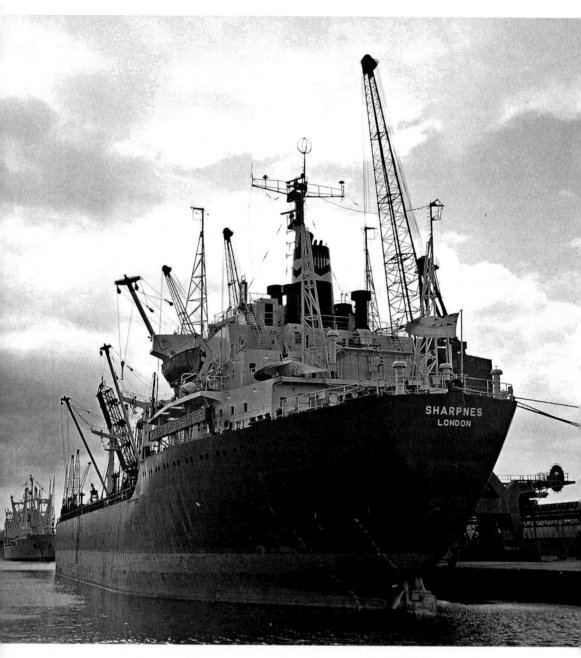

Jebsen Dillingham Shipping Ltd was a British subsidiary of the Norwegian company A/S Kristian Jebsens Rederi. Jebsen Dillingham managed several British-flagged bulk carriers. Seen at Avonmouth on 20 July 1980 was the *Sharpnes* (1973, 12,982grt), one of nine British-registered bulkers controlled by Dillingham.

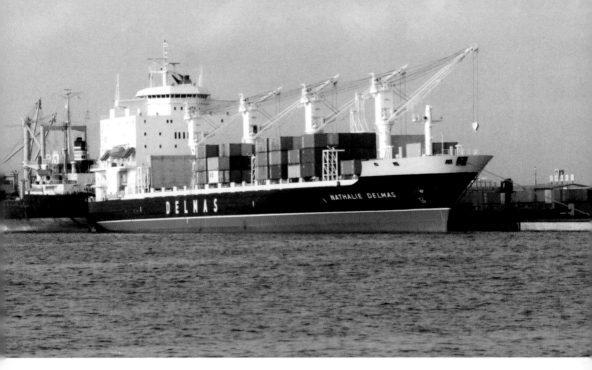

1 The stylish *Nathalie Delmas* (1982, 20,424gt) was alongside the SCNDV quay at Abidjan on 16 May 1982. SNCDV's West African trade was started in 1920 by Delmas Frères and became SNDV in 1947. Of the *Nathalie Delmas*, she was scrapped in 2003 as the MSC *Jessica*.

2 The general cargo/part-container ship *Jacqueville* (1978, 13,538grt) was seen in the Ebrié Lagoon on her way to the port of Abidjan on 14 March 1982. At the time, she was owned by SITRAM (Société Ivoirienne de Transport Maritime). Her subsequent career is unclear although, from her IMO number, she seems to be the *Shiri*, registered in St Vincent and the Grenadines.

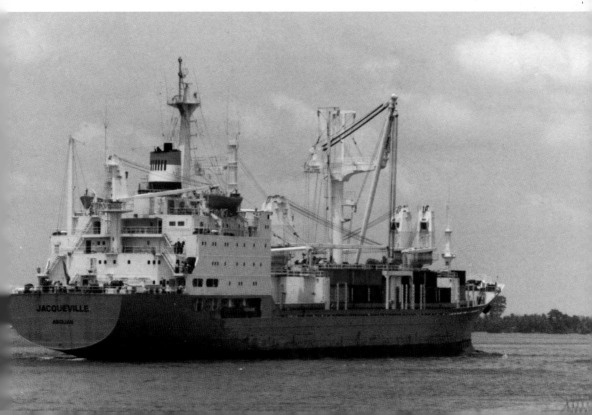

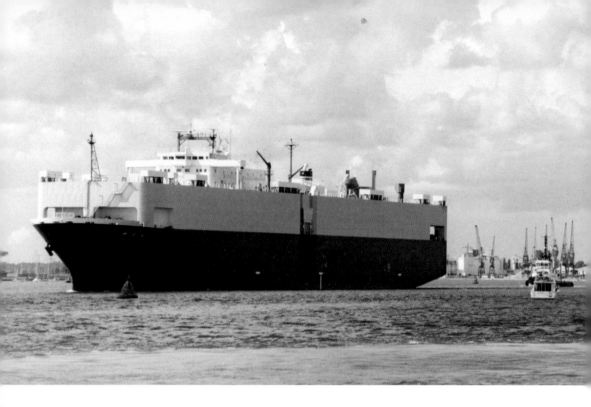

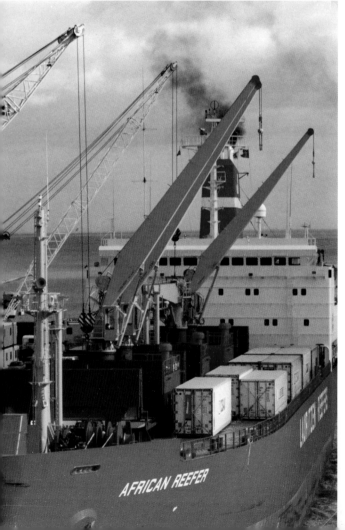

3 The vehicle carrier *Jingu Maru* (1992, 42,164gt) is seen leaving the East Docks in Southampton on 8 September 2001. She had been built by Kanasashi Co., Toyohatsu, as Hull 3275 and was operated by NYK. For scientific data collection, the *Jingu Maru* had a radiometer attached to her upperworks to acquire and record skin SST (sea surface temperature) data.

4 The Lauritzen Reefer pool vessel *African Reefer* (1985, 12,411grt) had been built by Hyundai Heavy Industries, Ulsan. She was equipped with four 8-tonne cranes and could also accommodate 148 TEUs. She is seen here at the Port of Dover in the mid-1990s.

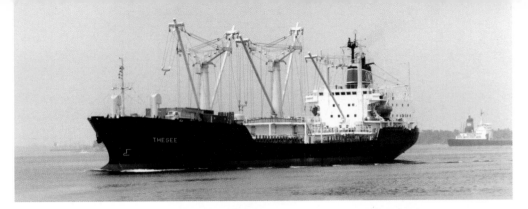

5 Leaving the Port of Abidjan and heading towards the Vridi Canal on 12 December 1982 was the SNC (Societe Navale Caenaise)'s ship *Thesee* (1980, 12,615t). A Neptun VEB Schiffswerft Type 421, she was with 'La Navale' from 15 November 1980 until 1991 when she was sold to Cie. Senegale Maritime. When this photograph was taken, an LDH (light dust haze) had descended on Abidjan.

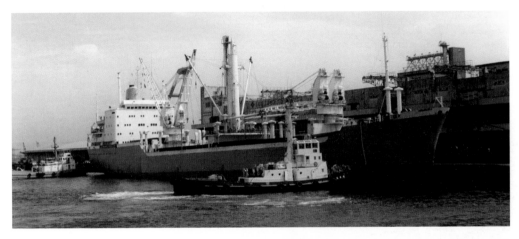

6 The Liberian-registered *Ariadne* (1971, 11,500t) is seen docking at Yokohama on 17 March 1979. She had been built as the *Norlanda* (Hull No.177) for Chargeurs Reunis by Framnaes shipyard at Sandefjord.

7 The Pakistan National Shipping Corporation's cargo-container ship *Hyderabad* (1980, 13,000grt) was seen in the harbour at Valletta on 14 January 1984. Built in Japan, it appears to still be part of the PNSC fleet.

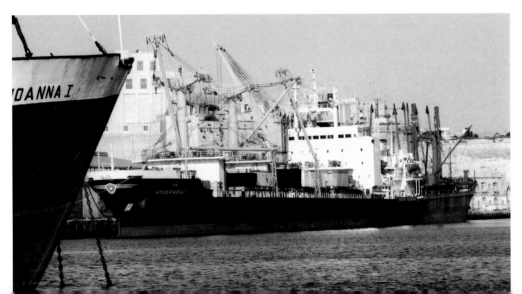

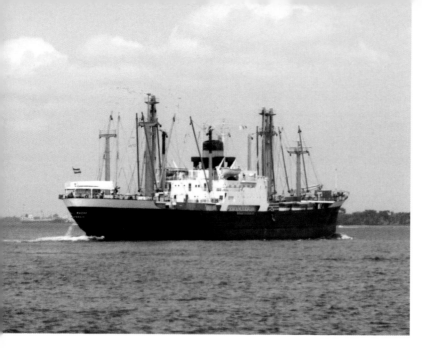

8 The *Nedlloyd Rhone* (1963, 9,900gt) was built at Howaldtswerke AG, Hamburg, and entered service as the *Neder Rhone*. She acquired the prefix *Nedlloyd* in 1979. She is shown here in the Ebrié Lagoon, heading to the Port of Abidjan on 16 October 1981. She became the *Saudi Al Madina* in the following year.

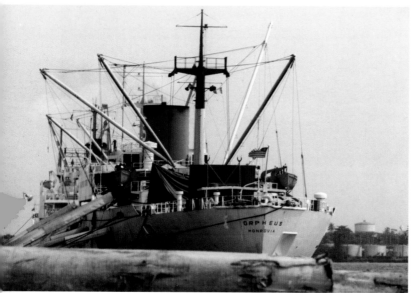

9 The *Orpheus* (1955, 5,500t; ex-*Ahrensburg*) had been built by Howaldtswerfe, Kiel. She is seen here loading pineapples at Abidjan in 1983.

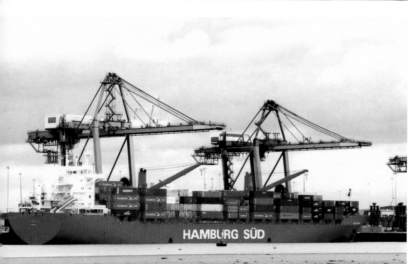

10 The Hamburg-Süd container carrier *Cap Polonio* (1990, 29,739gt, 33,221dwt) is shown at Berth 205 at Southampton Container Terminal. Built by Flender-Werft at Lübeck, she has a capacity for 2,023 TEUs and 267 reefer plugs.

11 Berth 40 at Southampton on 4 June 2002 was occupied by the Wilhelmsen Ro-Ro vessel *Toba* (1979, 22,008gt). Launched as the *Barber Toba*, she operated on the Barber Blue Sea service. Initially designed to carry high, heavy cargo, containers, trucks and cars, she had extra car decks added in 2004.

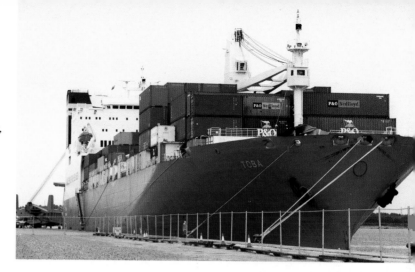

12 In the Eastern Arm of Royal Edward Dock, Avonmouth, on 27 January 1980 was the Pacific Steam Navigation Co.'s *Orbita* (1972, 12,321gt), moored astern of the *Cap Breton*. Furness Withy acquired the Royal Mail/PSNC Group in 1965 and vessels were frequently switched between constituent companies. By 1984, however, PSNC's name had been abandoned. Built by Cammell Laird, Birkenhead, the *Orbita* was sold to Cia. Sud-Americano dos Vapores in 1980 and renamed *Andalien*. Further changes of ownership took place in the same year when she was sold to Wallem & Co., Hong Kong.

13 In 1993, Geest Bananas (Geest Line) moved port operations from Barry to Southampton. Seen here at her assigned berth (101) on 10 June that year was the *Geestbay* (1981, 7,891grt). Built by Smith's Dock Co., South Bank, Middlesborough, she was a handsome vessel which, on completion, was moored in the Pool of London as an example of the work of British shipyards.

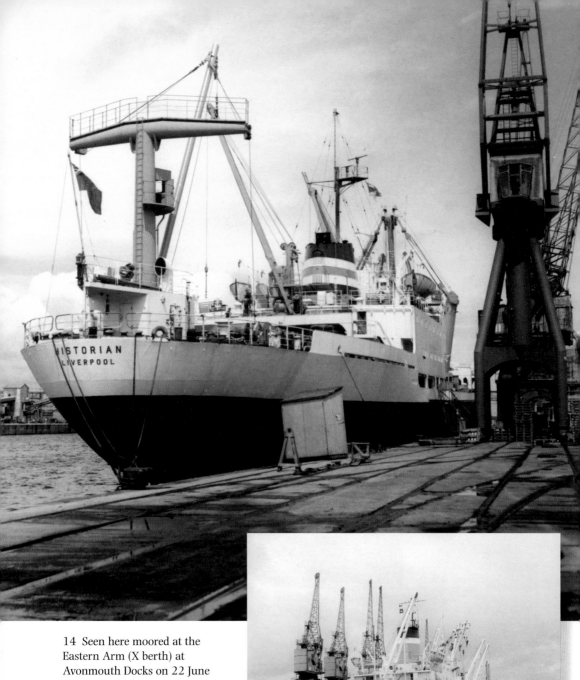

14 Seen here moored at the Eastern Arm (X berth) at Avonmouth Docks on 22 June 1980, Harrison Lines' *Historian* (1968, 8,454gt) was the fifth Harrison vessel to bear this name. A product of Doxford and Sunderland Shipbuilding and Engineering Co. Ltd (Yard No.885), she was sold in 1981 to Bunga Shipping Co. (Pte) Ltd (Madame Dolly Seah), Singapore and renamed *Cherry Orient*. The vessel was sold for demolition in 1985.

15 *The City of London* (1970, 7,415gt) is seen at Q berth at the Royal Edward Dock, Avonmouth, on 14 August 1980. Built by Upper Clyde Shipbuilders Ltd, she was one of the last three deep-sea cargo liners for Ellerman.

16 The Baie du Banco was an extension of the Ebrié Lagoon. It was the preferred location in Cote d'Ivoire for the loading of hardwood logs felled in the interior of the country. On 6 December 1982, Zim Israel Navigation's *Negba* (1977, 10,604grt) and the Panama-registered *Sea Triumph* were moored, ready to receive their cargoes of logs.

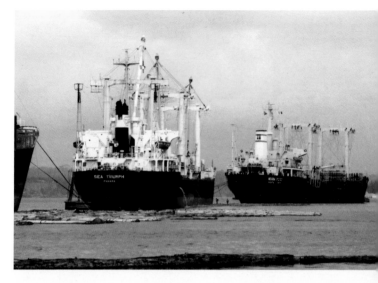

17 A late afternoon at Grand Bassam (Cote d'Ivoire) in November 1981 saw the Portuguese ship *Alcoutim* (1968, 10,518 grt), having left Abidjan, heading east along the coast. Off the Ivoirian coast, there were features of significant oceanographic interest. For example, the Trou Sans Fond sub-sea canyon lies to the east of Abidjan: there is also a current (the Ivoirian undercurrent) that runs east-to-west in a sub-surface layer counter to the west-east/south-east Guinean Current.

18 Seen from the Marchwood Yacht Club, the Liberian-registered *APL Ireland* (2002, 67,500gt) was being manoeuvred in the Upper Swinging Ground at Southampton on 21 June 2004. Built by the Koyo Dockyard Co. Ltd (Hull No.2141), she has a container capacity of 5,928 TEUs.

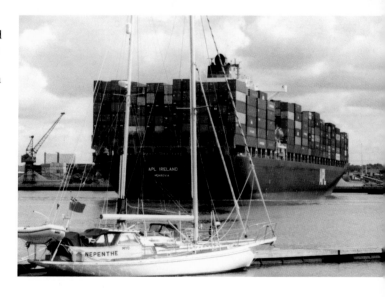

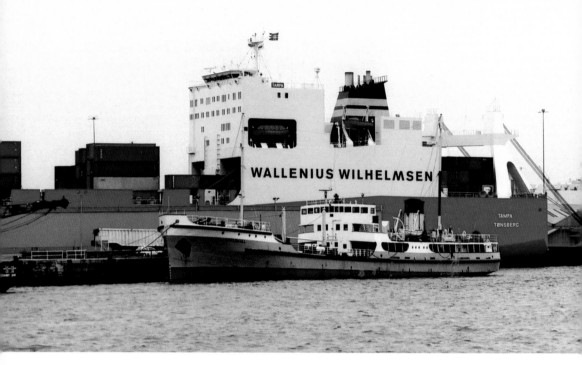

19 Wm. Wilhelmsen's *Tampa* (1984, 28,287gt) was the fifth Wilhelmsen vessel to carry the name. Launched by Hyundai Heavy Industries Co. Ltd, Ulsan, as the *Barber Tampa*, she had a capacity for 2,451 TEUs. She is shown here at Berth 40 in the Eastern Docks at Southampton.

20 A late afternoon at what is now the City Cruise Terminal at Southampton West Docks saw *Saga Rose* (1965, 25,147gt) taking bunkers from John H. Whitaker's *Whitchallenger* (2002, 2,958gt).

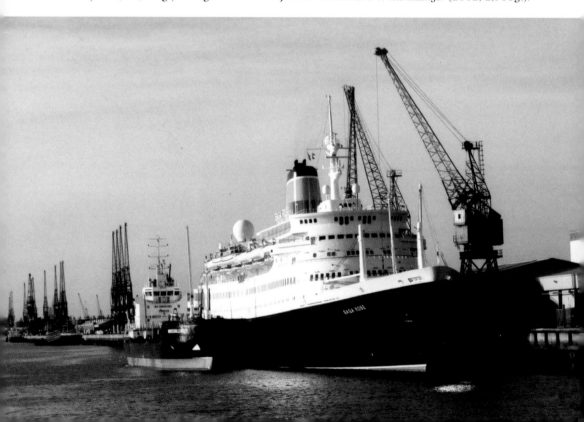

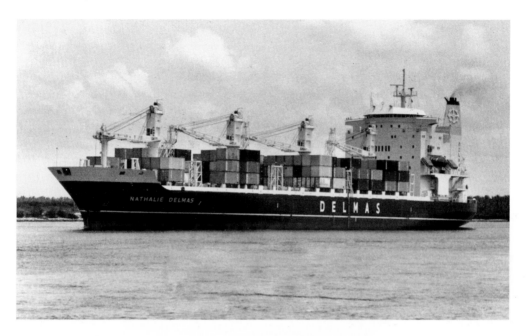

One of SNCDV's (Société Navale et Commerciale Chargeurs Delmas-Vieljeux) elegant and well-presented ships, the *Nathalie Delmas* (1981, 20,424t) was seen outward-bound in the Vridi Canal (connecting the Port of Abidjan, Cote d'Ivoire, located in the Lagune d'Abidjan, with the sea) in November 1982.

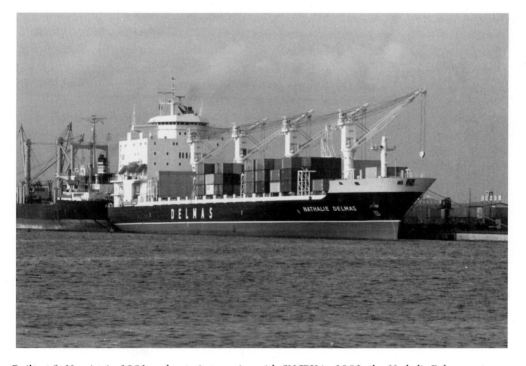

Built at St Nazaire in 1981 and entering service with SNCDV in 1982, the *Nathalie Delmas* was seen moored in the port of Abidjan on 14 March 1982 after one of her first voyages.

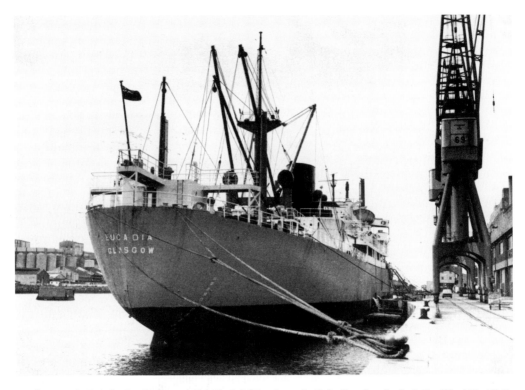

Anchor Line's *Eucadia* (ex-*Linkmoor*) (1961, 8,155grt) was built by Barclay Curle & Co. (Yard No.704). She is seen here in the Royal Edward Dock, Avonmouth, on 22 June 1980. In 1982, she was sold to Athinia Shipping, Sri Lanka, and was scrapped in 1983.

Opposite: The Togolese ship *Pic d'Agou* (1978, 7,600gt) waited in the lock at Ouistram, near Caen, on 13 July 1987 with the tug *Appelant* in attendance. Owned at the time by the state shipping company Cie. Sotonam, she was named after the highest point in Togo.

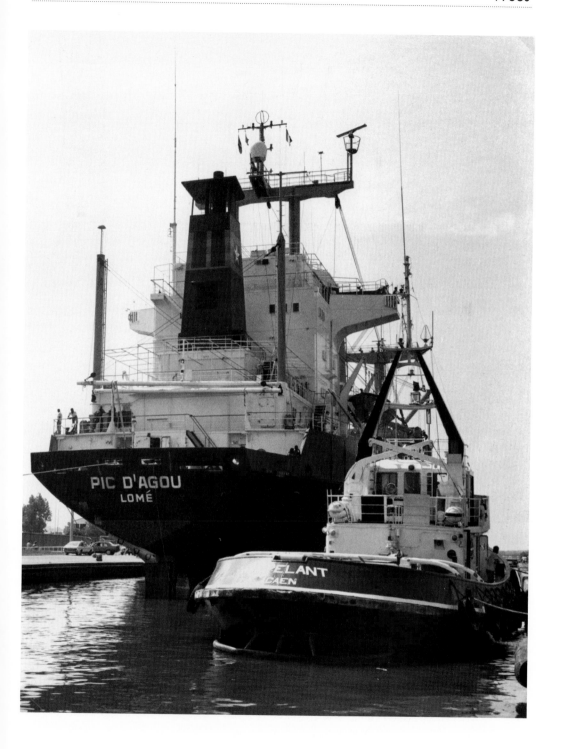

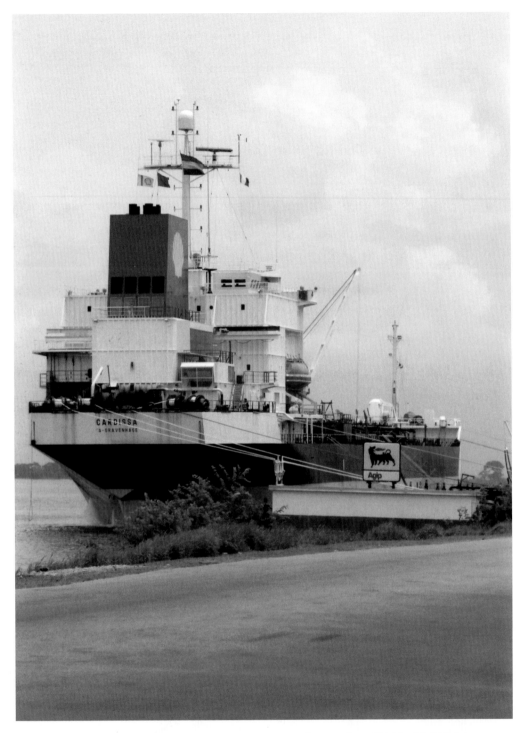

The Shell International Trading and Shipping Co.'s tanker *Cardissa* (1983, 22,290t) is seen at PETROCI's Vridi Oil Maritime Terminal that lay about 4km from Abidjan. The *Cardissa* was constructed by Schelde Rijn & Verolme (Hull No.987) for Shell Tankers, Rotterdam. It was eventually sold in 2004 to Capital Ship Management.

The *Pic d'Agou* was reflected in the Ouistram Canal as she continued her journey to Caen, assisted by the *Appelant*.

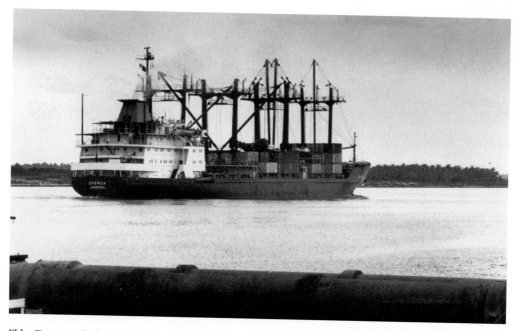

Elder Dempster's *Shonga* (1973, 9,239grt), on the UKWAL service, was in-bound for Abidjan in the Vridi Canal in November 1981. The third ED ship to carry the name, she was sold to Liberia in 1984 and renamed *Aroma*. She had six further name changes and was broken up at Guangzhou in 1997.

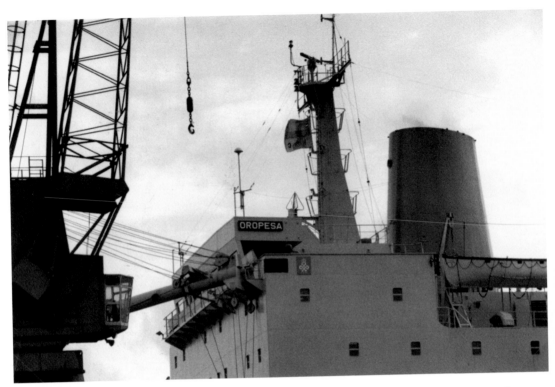

Pacific Steam Navigation Co. (PSNC)'s *Oropesa* (1978, 14,124grt) was in dry dock at Avonmouth on 22 June 1980. A plaque displayed by the portside navigation light indicated that the company had received the Queen's Award to British Industry for 1974.

Opposite above: On the last day of November 1980, PSNC's *Andes* (1973, 8,396grt) was docked at Avonmouth. Built by Cammell Laird & Co. at Birkenhead as the *Ortega*, she became the *Andes* in 1980. In 1982 she was further renamed and became the *Oceanhaven* in August of that year.

Opposite below: Moored at Abidjan on 28 March 1982 was Elder Dempster's *Sapele* (1980, 9,240gt, IMO 7720087). She had been built by Warkiego in Szeczin as a 'Combo' ship. She appears to still be in service, having been renamed *Astroman* in 1998.

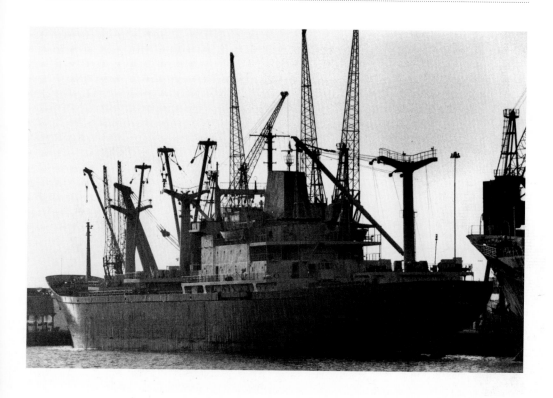

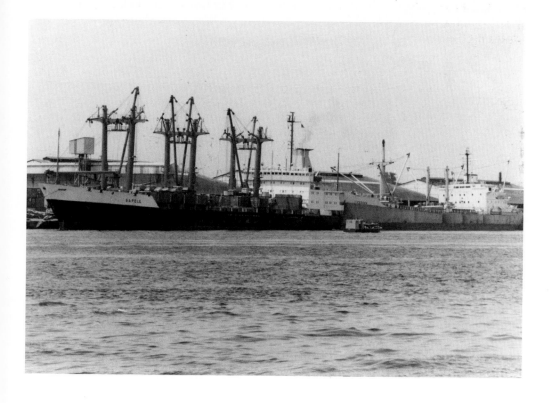

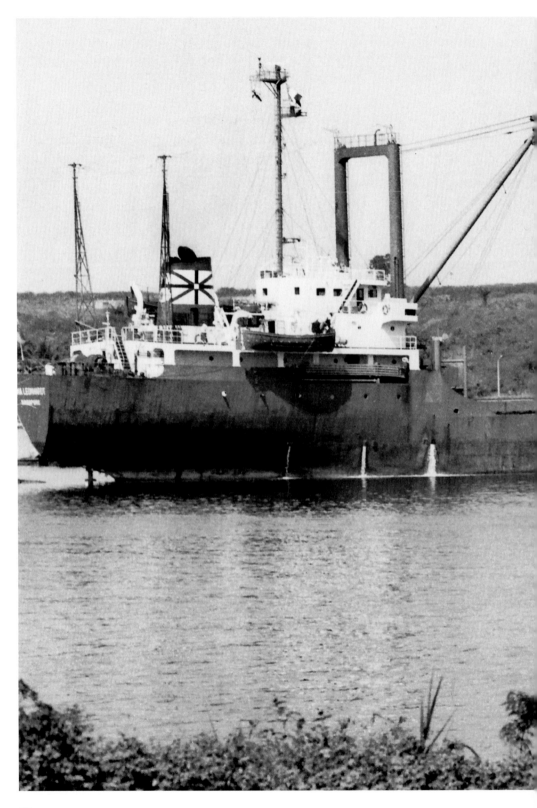

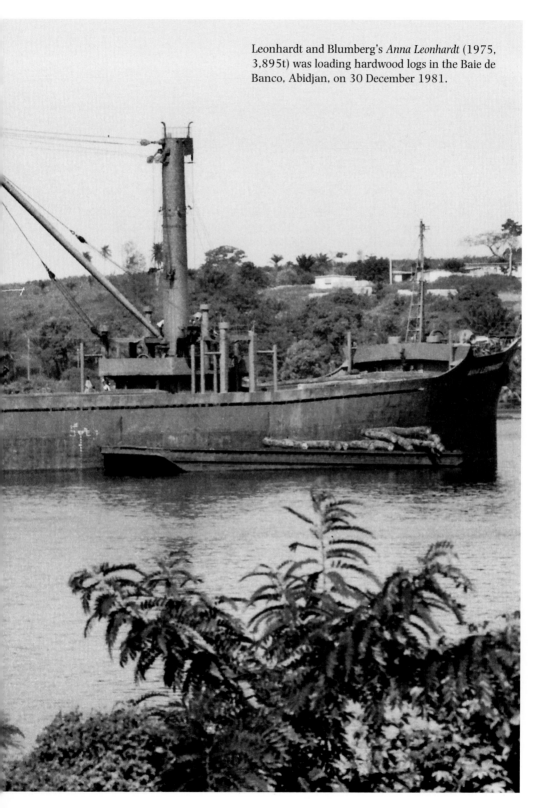

Leonhardt and Blumberg's *Anna Leonhardt* (1975, 3,895t) was loading hardwood logs in the Baie de Banco, Abidjan, on 30 December 1981.

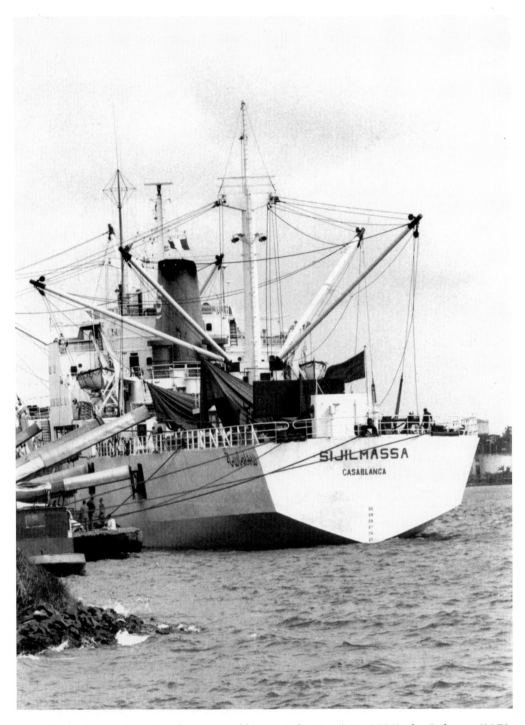

Owned by Union Maritime Scandinave, Casablanca, at the time (May 1983), the *Sijilmassa* (1972, 6,682gt) was loading tropical fruit at the port of Abidjan. Formerly the *Kungshamn* (1976) and *Lapland* (1975), she carried the name of the walled oasis city founded in Morocco in AD 757 where caravans that crossed the Sahara were organised.

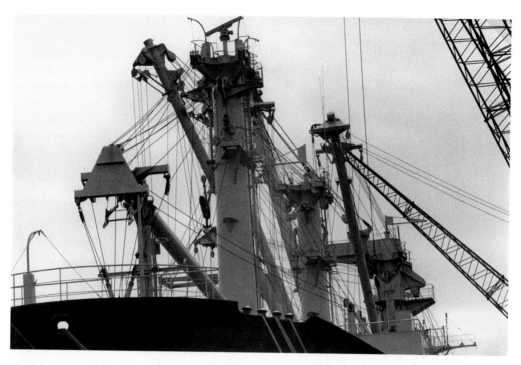

The lifting gear of the *Oropesa* (1978, 9,015t) is seen in detail when the vessel was at Avonmouth on 22 June 1980. She had been built by Lithgows Ltd at Port Glasgow. At the time she was working on Shaw, Savill and Albion services.

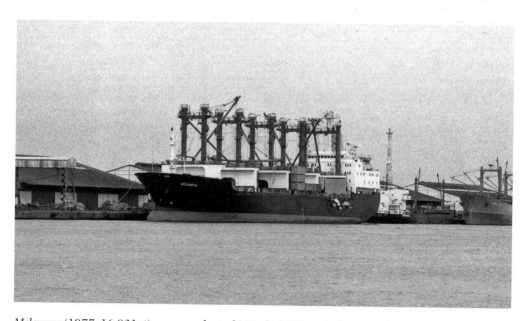

Melampus (1977, 16,031gt) was a product of Mitsubishi Heavy Industries. She was one of four vessels delivered on charter to Ocean Fleets Ltd from Airelease International (Moorgate) Ltd (a BP subsidiary). Seen here at Abidjan on 21 October 1981, she was operated by Barber Blue Sea with Elder Dempster as managers.

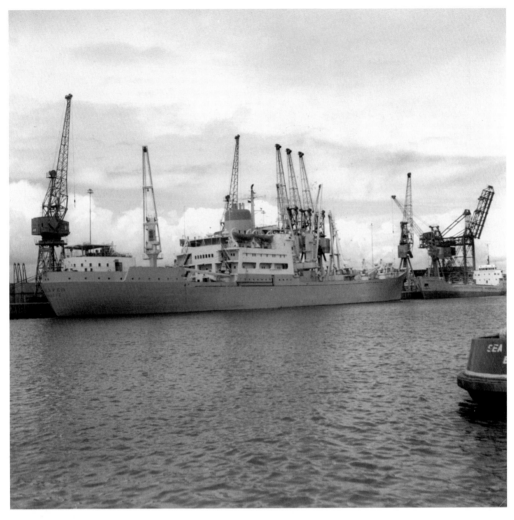

Transatlantic Rederei A/B's motor ship *Hallaren* (1960, 8,760dwt) had been built by OY Gotaverken, Gothenburg (Yard No.752). She had been sold to Arundel Maritime, Greece, in 1977 but was re-chartered by Transatlantic Rederei. She was moored at Berth 4 in the Eastern Arm of Avonmouth Docks on 22 June 1980.

Opposite above: Formerly Union Castle's *Good Hope Castle*, the *Paola C* was in the Royal Edward Dock at Avonmouth on 20 July 1980. A product of Swan Hunter, she had been sold to Costa Armatori SpA of Genoa in 1978 and renamed after a lengthy period of lay-up in the Western Docks at Southampton.

Opposite below: The *NZ Waitangi* (1967, 12,228gt) was in the Eastern Arm of the Royal Edward Dock, Avonmouth, on 2 March 1980. Formerly Shaw Savill Line's *Britannic*, she was part of an intra-company transfer, together with the *Majestic* (*NZ Aorangi*).

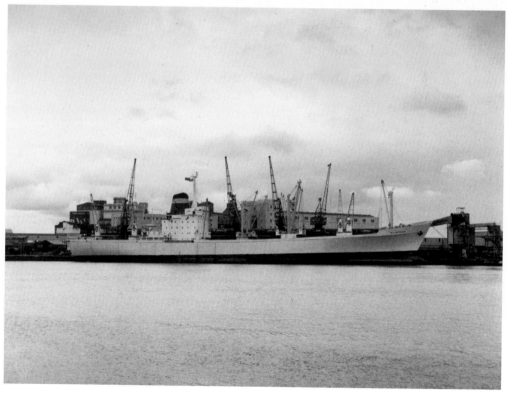

In the Royal Edward Dock on 20 July 1980 was the Fyffes Group reefer *Musa* (1971, 6,510gt) and the King Line's (Clan Line Steamers Ltd) *Clan Graham* (1961, 9,022gt).

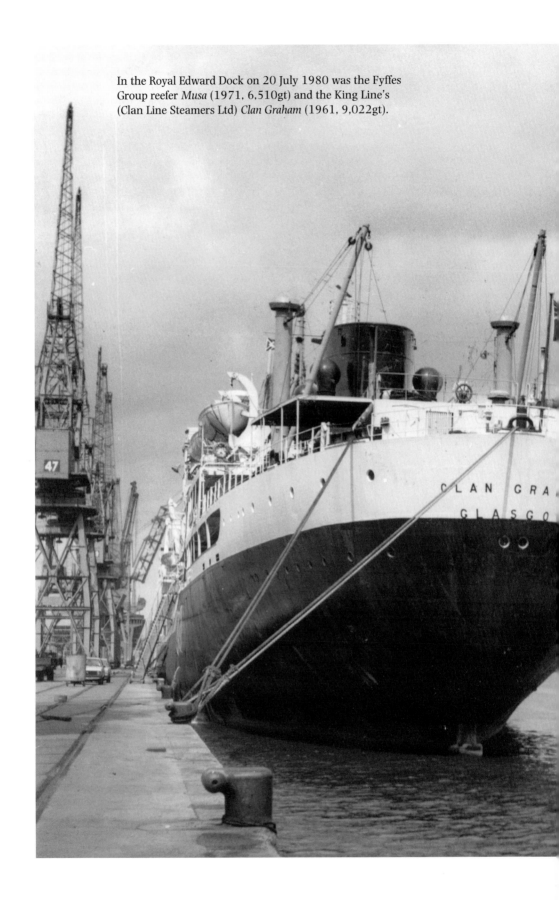

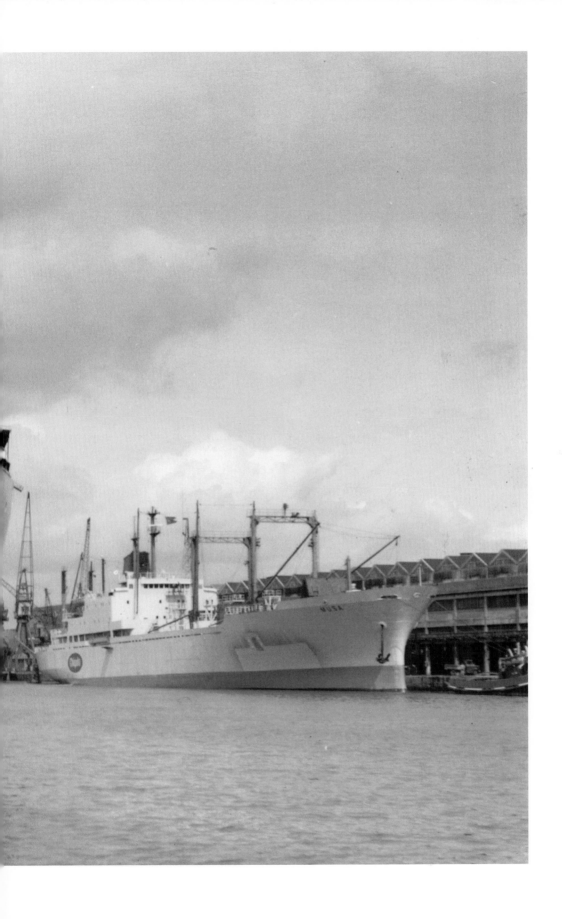

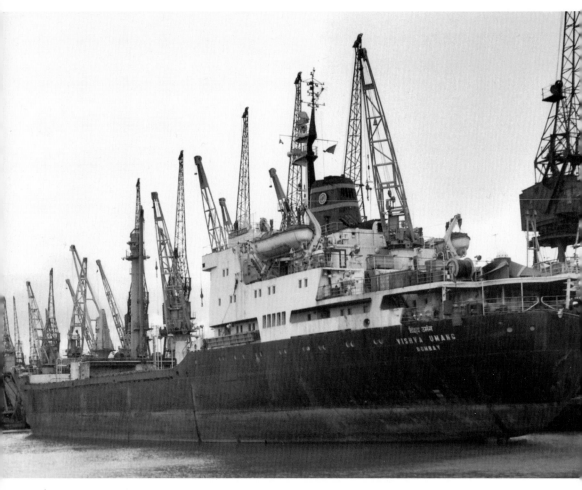

Indian ships were frequent visitors to Avonmouth Docks. On 22 June 1980, the Shipping Corporation of India's *Vishva Umang* (1973, 9,965gt) was moored in the Eastern Arm.

Opposite above: Black Star Line was crucial to Ghana's maritime sector in the 1960s and '70s. It collapsed, however, allegedly under the weight of colossal debt and dreadful mismanagement. Nevertheless, a Ghanaian ship, the Takoradi-registered *Ferial*, was waiting in the Baie de Banco, Abidjan, in the early 1980s.

Opposite below: A product of Stocznia Szczecinska, the Soviet ship *Vera Lebedeva* (1975, 6,555gt) was at Abidjan on 21 February 1982.

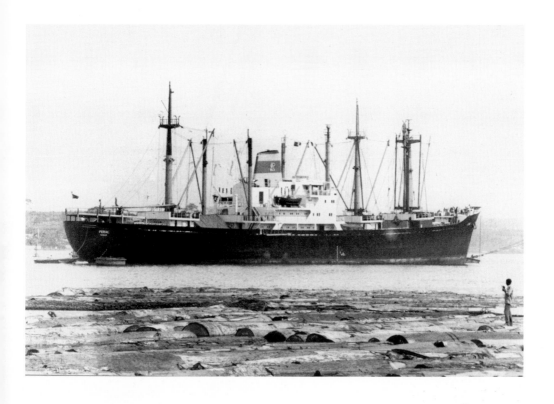

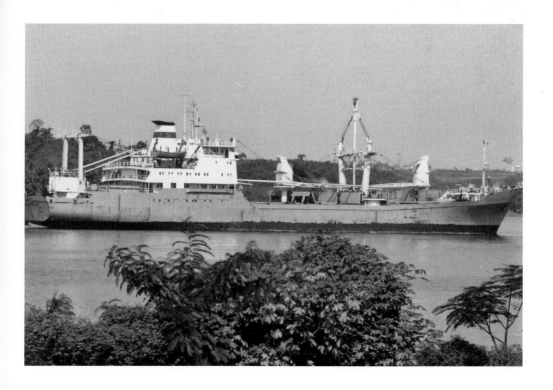

Seen here at Avonmouth on 20 July 1980 was
the Sudanese *El Obeid* (1979, 9,691gt). Built
at 3 Maj Brodogradiliste shipyard, Rijeka (Yard
No.991), it was owned by Sudan Shipping Line
Ltd. In 2002 the vessel was sold and broken up
in Alang in India.

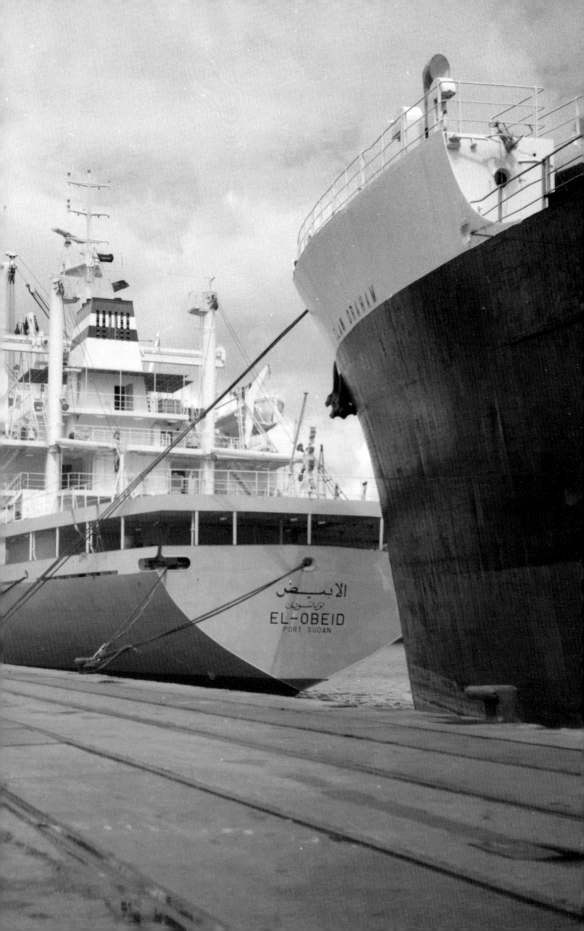

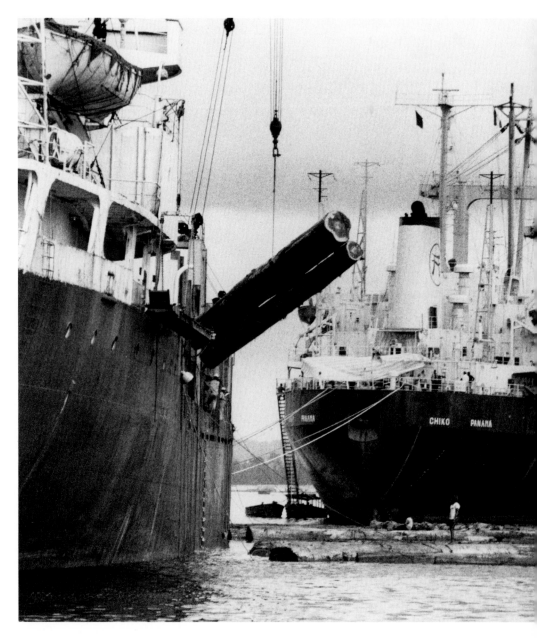

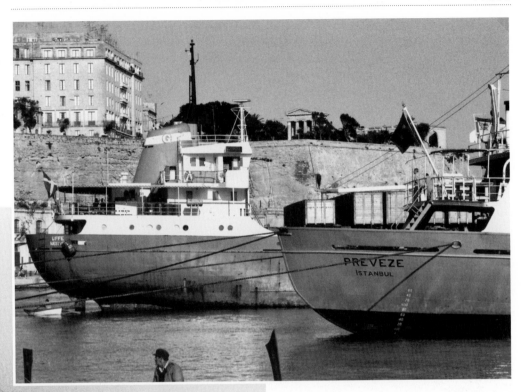

Above: With the Upper Barracca Gardens in the background, a pair of coasters were moored in Grand Harbour, Valletta, in 1984.

Left: The export of tropical hardwoods was an on-going activity in the Port of Abidjan. Here the Panamanian *Chiko* waits her turn whilst the loading of another vessel takes place.

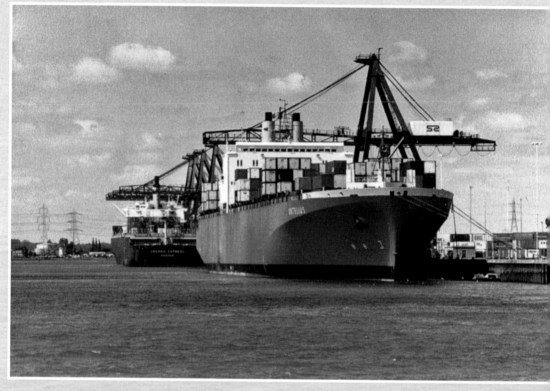

Container ship *Ortelius* (1978, 52,444t) was jointly owned by DAL (Deutsche Afrika Linien GmbH) and CMB (Compagnie Maritime Belge SA). She worked, however, in CMB's colours. She was seen at Southampton, with Hapag-Lloyd's *Bremen Express* (1972, 57,535t), at Berths 204 and 206, respectively.

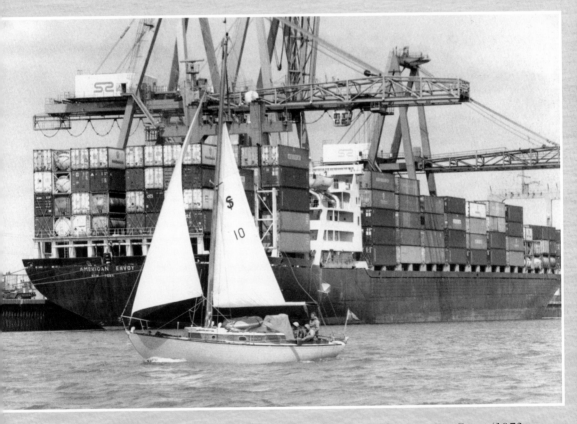

On 7 May 1984, at Berth 201/2, the United States Line container ship *American Envoy* (1972, 30,990gt) (formerly Farrel Line's *Austral Envoy*) was moored at Southampton with a full load of containers.

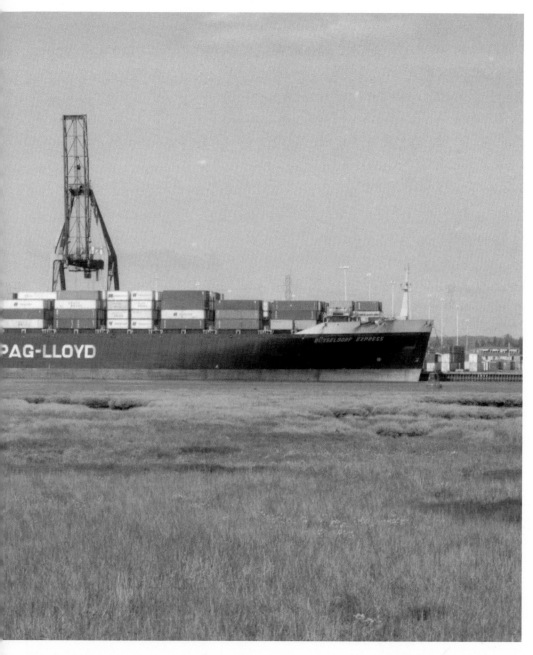

Above: Hapag-Lloyd's *Düsseldorf Express* (1977, 32,928gt) was a striking-looking vessel. She is seen here at Southampton on 24 October 1983, probably at Berth 206.

Left: The ore/oil carrier *Tantalus* (1972, 120,787gt) was owned by China Mutual Steam Navigation Co. (a part of Blue Funnel Bulkships Ocean Transport). She spent about two years (1982–84) laid up in Ocean Dock, Southampton, where she was seen in August 1982.

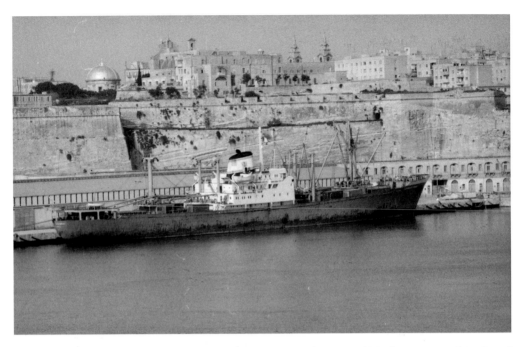

Empresa Lineas Maritimas Argentina's *Almirante Stewart* (1967, 6,531gt) was moored in Grand Harbour, Valletta, on 22 January 1984.

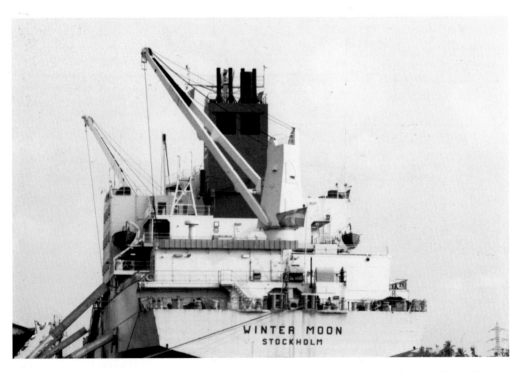

Salen's *Winter Moon* (1979, 14,800dwt) was the first of the 'Winter' series of reefer ships. She was loading tropical fruit in the Port of Abidjan on 14 November 1981.

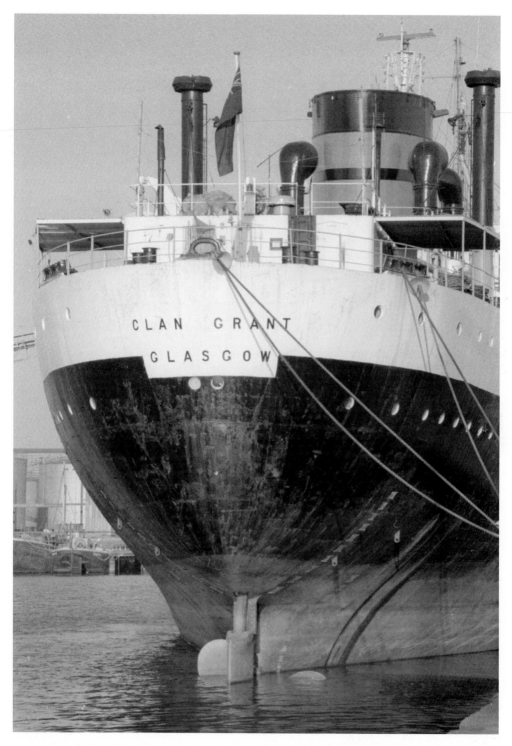

Clan Grant (1962, 9,022gt) was built for Cayzer, Irvine & Co. Ltd by Greenock Dockyard & Co. Ltd (Yard No.499). She was the fourth Clan Line vessel to carry the name. In 1977, she was transferred to King Line but reverted to Clan Line in 1981. Sheis shown here in Avonmouth Docks on 30 November 1980.

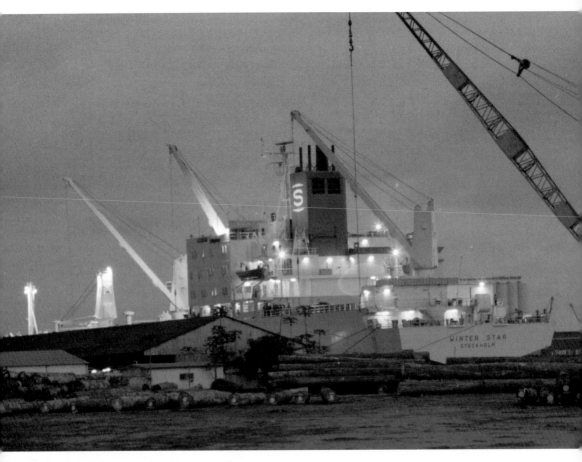

One of Salen's refrigerated cargo vessels, the *Winter Star* (1979, 15,300dwt), was loading fruit at Abidjan on the evening of 21 November 1982.

Chapter 4

1990s

VILLE DE VIRGO
PORT AUX FRANCAIS

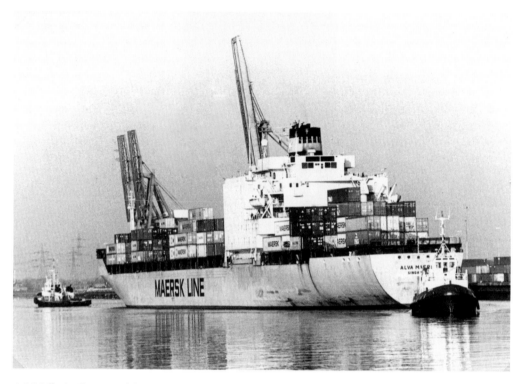

A.P. Moller's *Alva Maersk* (1976, 34,382grt) was being manoeuvred from Berth 204 at Southampton at 10a.m. on 29 December 1992. Built by Flenderwerft AG, she had a container capacity capacity of 1,399 TEUs.

Opposite above: Having left Berth 204, the *Alva Maersk* was turned in the Western Swinging Ground (off Berths 201 and 202 of the Test Quays).

Opposite below: At Berth 205 at Southampton on 24 November 1991 was the Danish East Asiatic Co. (Det Ostasiatiske Kompagni)'s *Toyama* (1972–84, 52,196gt; 1984–2001, 57,123gt). Built for Wilh. Wilhelmsen by Mitsui Zosen, Tamano (Yard No.900), her post-1984 container capacity was 2,666 TEUs. She had been sold to EAC in April 1991. In 1993, she was sold to A.P. Moller and became the *Maersk Nanhai*.

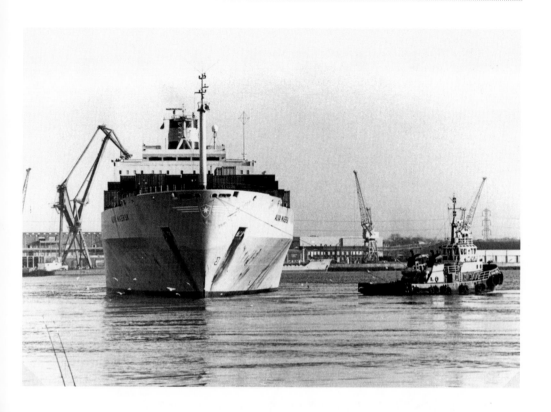

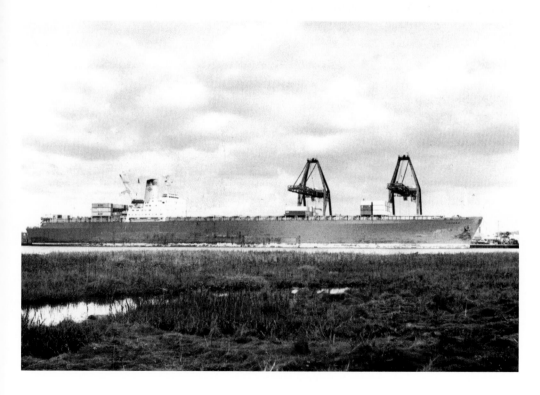

On 3 May 1993, a surprisingly rusty *Ladby Maersk* (1972, 55,241grt) was moored at Southampton's container terminal. She had been launched as the *Nihon* for Transatlantic Rederi A/B.

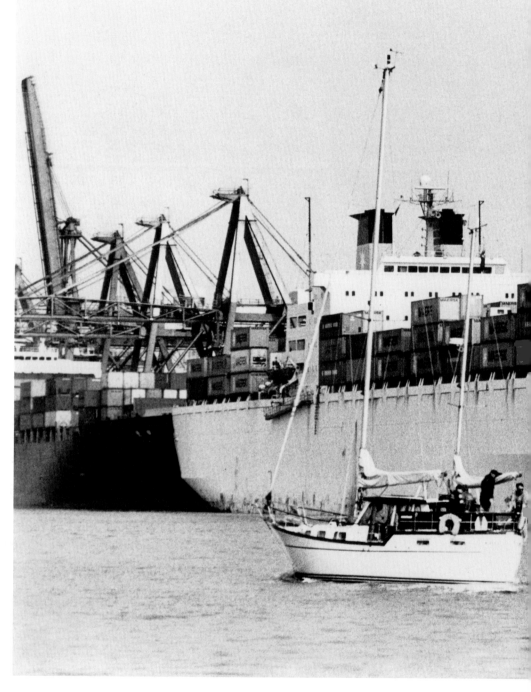

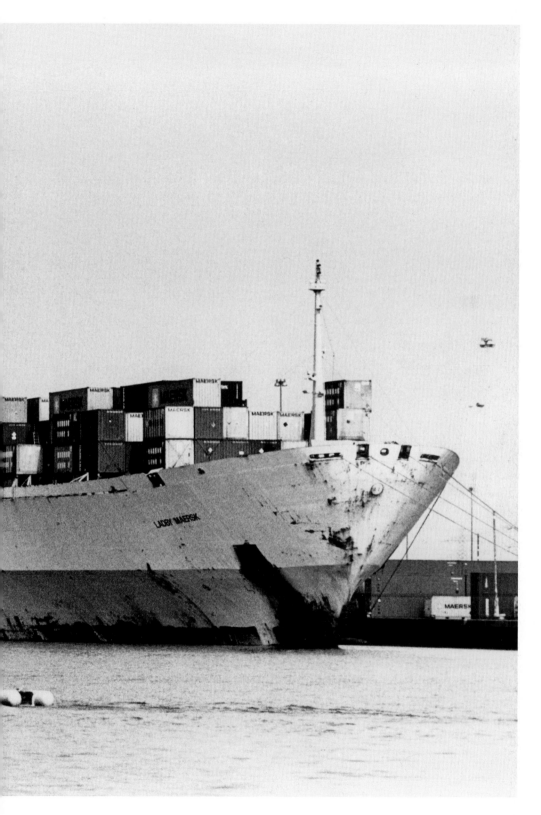

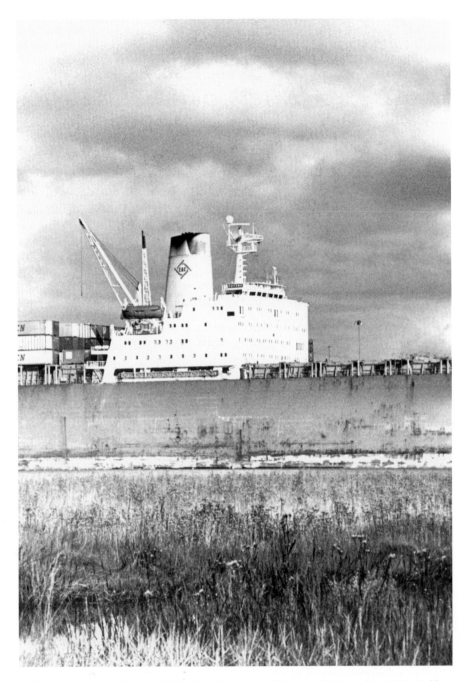

A closer view of the *Toyama* (1972, 52,196gt) from Eling on 24 November 1991. Sold to
EAC in April 1991, she was sold again in 1993 and became A.P. Moller's *Maersk Nanhai*.
She was renamed *Nanhai* in 1999 and broken up from October 2001.

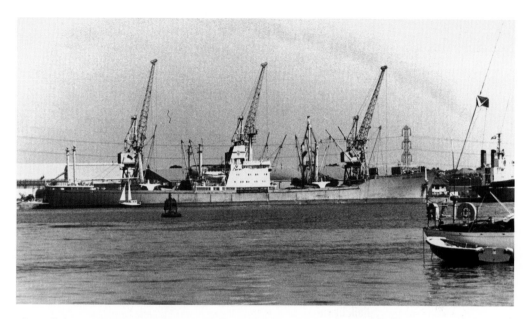

The Polish vessel *Major Sucharski* (1974, 8,756t) was moored at Berth 107 at Southampton on 8 September 1991. She had been built by Stocznia Gdynia, Gdynia.

The steel-masted barque *Viking* (1907, 2,952grt) had been built by the Burmeister and Wain shipyard in Copenhagen. She is seen here at Lilla Bommen, Gothenburg in April 1999. A pleasantly symmetric picture is made with the *Viking* and the Columbus Ship Management GmbH's reefer *Polar Colombia*.

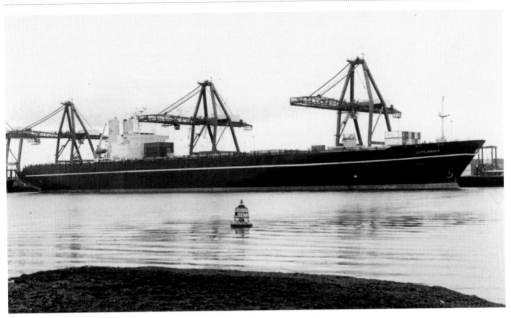

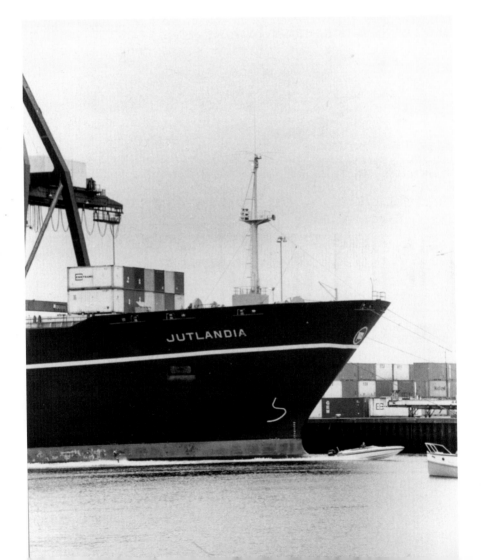

Opposite above: The first-generation container ships *Jutlandia* and *Sealandia* were elegant vessels and, at the time, their service speed of 28.2kt made them the two fastest merchant ships on the ocean. Built by Burmeister and Wain, Copenhagen (Yard No.846), the *Jutlandia* (1992, 49,890gt) was delivered in 1972.

Opposite below: A further view of EAC's *Jutlandia* at Berth 204 on 30 June 1991. As part of the ScanDutch consortium, Southampton was one of their ports of call.

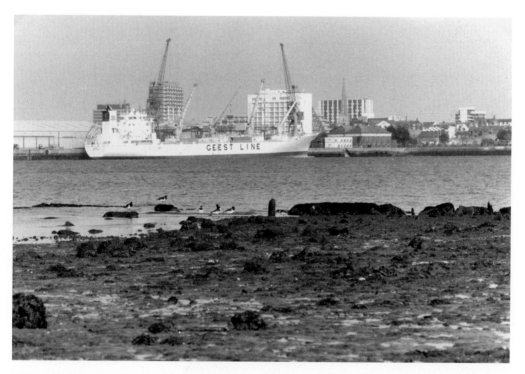

With a group of oystercatchers in the foreground, the reefer *Elke* (1994, 8,665t) was at the Windward Terminal at Southampton on 28 March 1999. Launched as the *Chiquita Elke*, she carried the name *Elke* from 1997–99.

Geest Line's *Geest St Lucia* (1993, 13,077gt) was seen at
the Windward Terminal on 1 June 1993. Built by Danyard,
Frederikshavn (Yard No.720), she had been delivered in
the previous February. She was renamed *St Lucia* in 1997.

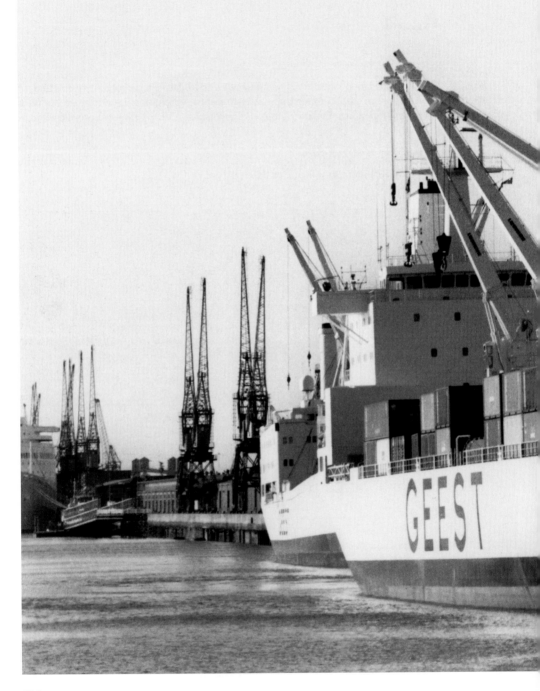

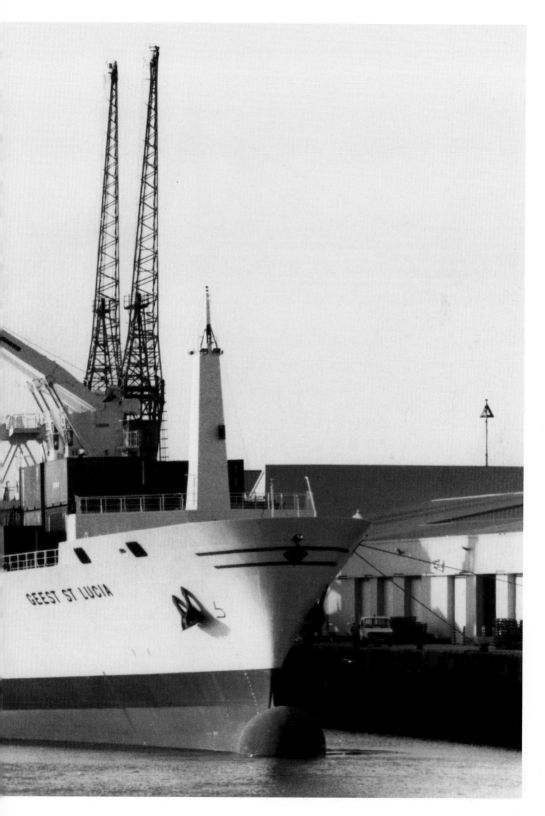

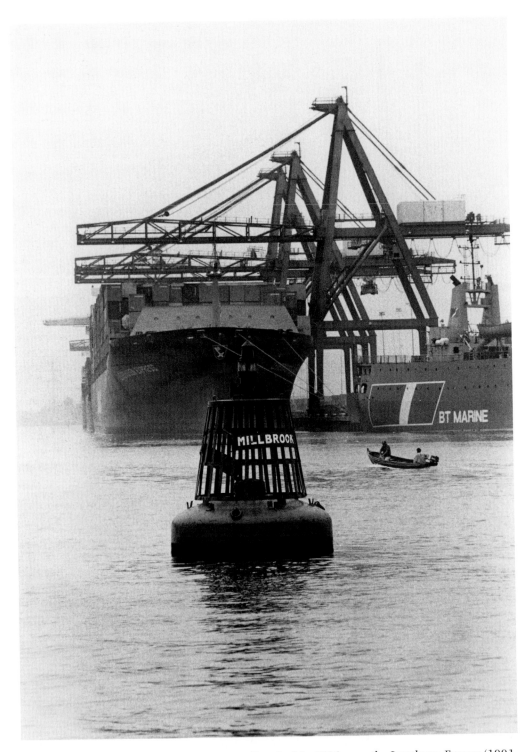

Seen at Berth 204 at Southampton Container Terminal in 1991, was the *Leverkusen Express* (1991, 53,783gt, IMO 8902541). Built at the yards of Samsung Shipbuilding and Heavy Industries, Koje (Yard No.1076), she was operated by Hapag Lloyd.

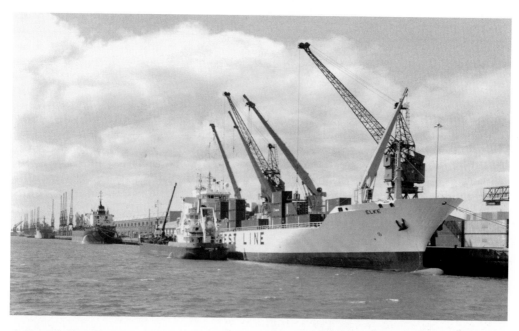

A view of the *Elke* (1994, 8,665t) seen at the Windward Terminal taking bunkers from Whitaker's *Jaynee W*. At Berth 103 was Stephenson Clarke's *Jevington* (1977, 7,702gt), which had been towed into port on 5 June 1998 following a crankcase explosion off Beachy Head. She was scrapped in Spain in 2000.

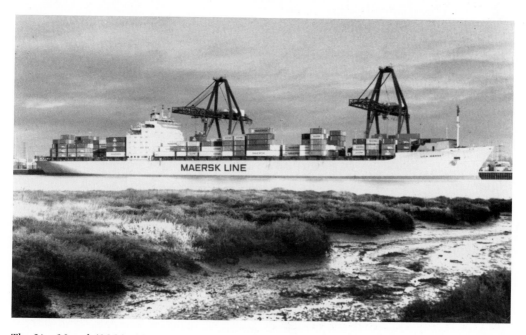

The *Lica Maersk* (1981, 43,325gt), seen at Berth 205 at Southampton on 13 December 1992, had been built by Odense Staalskibsvaerft, Lindo (Yard No.86). She was acquired by the US Navy in 1997 and converted to a Ro-Ro cargo ship. She was renamed USNS *Soderman*. She was further modified in 2001 and is now in service as the *Gy. Sgt. Fred W. Stockham*.

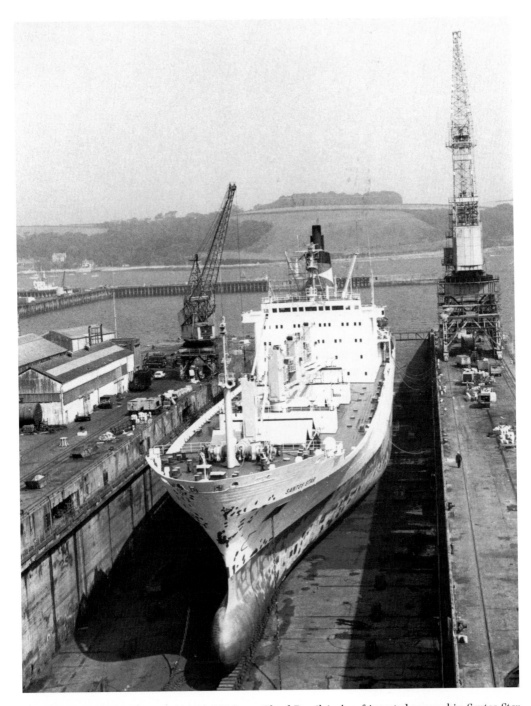

In dry dock at Falmouth on 2 August 1990 was Lloyd Brasileiro's refrigerated cargo ship *Santos Star* (1972, 14,512grt). A ship which underwent many changes of identity (ex-*Snow Delta*, *Limari*, *Blue Sea* and others), she was broken up at Alang in 2006.

Falmouth is ideally situated for the reefer trade, being on the ballast route between northern Europe and the Canaries, the Caribbean and South Africa.

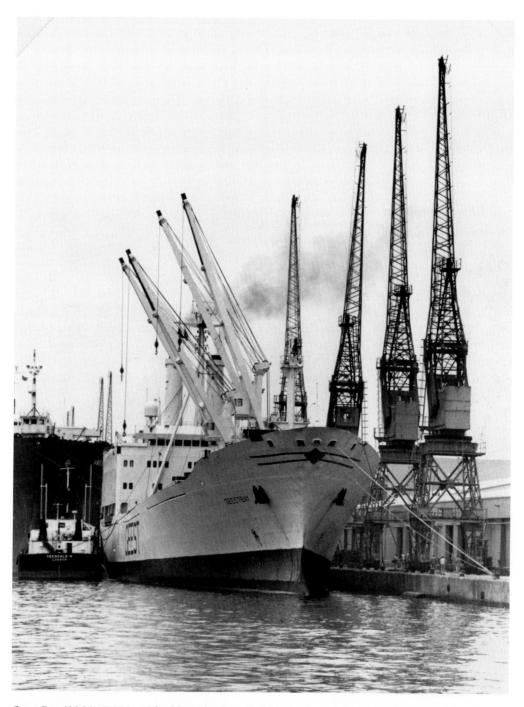

Geest Bay (1981, 7,891grt) had been built at Smith's Dock, Middlesborough (Yard No.1346). She and her sister ships were handsome vessels. She is seen here at Windward Islands Terminal on 30 August 1993.

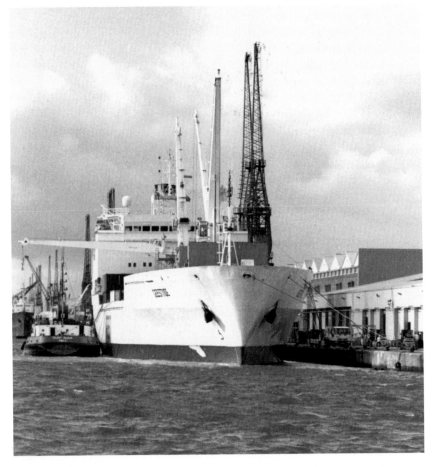

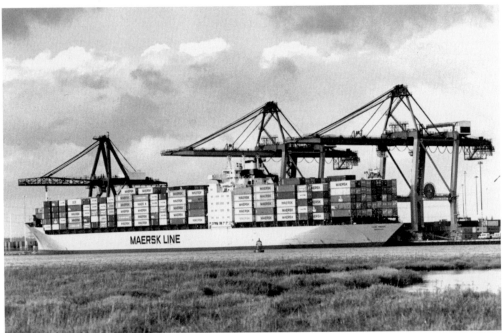

The bulk carrier *Olympic Melody* (17,879gt) was in Immingham docks in May 1999. A 'railway dock', it was opened in 1912 by the Manchester, Sheffield & Lincolnshire Railway to serve to serve those cities and their hinterland.

Opposite above: Geest Line had moved its port operations from Barry to Southampton in 1993. At the company's assigned berth (101) in July 1995 was the *Geesttide* (1993, 10,614gt). Launched as the *Horncloud* from the Gdansk Shipyard, she became the *Coral Universal* (1994), *Horncloud* (1995), *Coral Reef* (1998) and *Dunbar Star* (2003).

Opposite below: Leise Maersk (1983, 43,233gt) had been built by Lindovaerfvet, Odense. She was lengthened in 1987 by Hyundai. She was seen at Southampton Container Terminal on 2 January 1994. In 1997, she was bought by US Military Sealift Command.

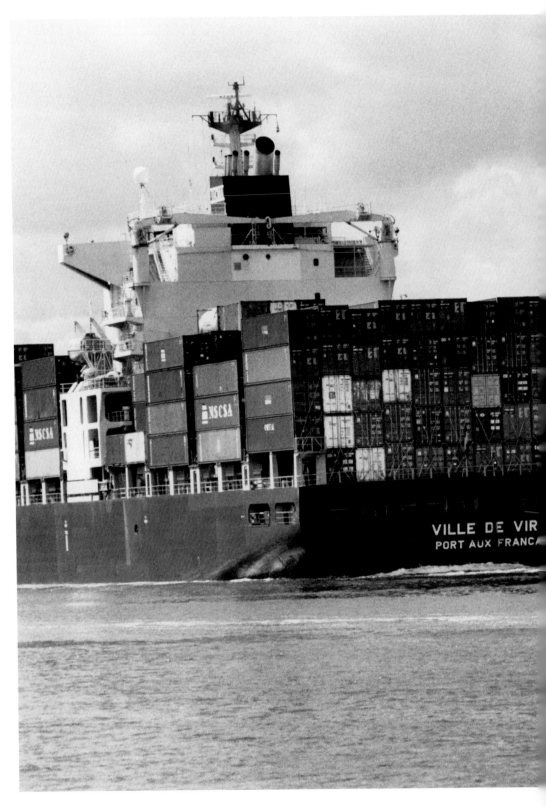

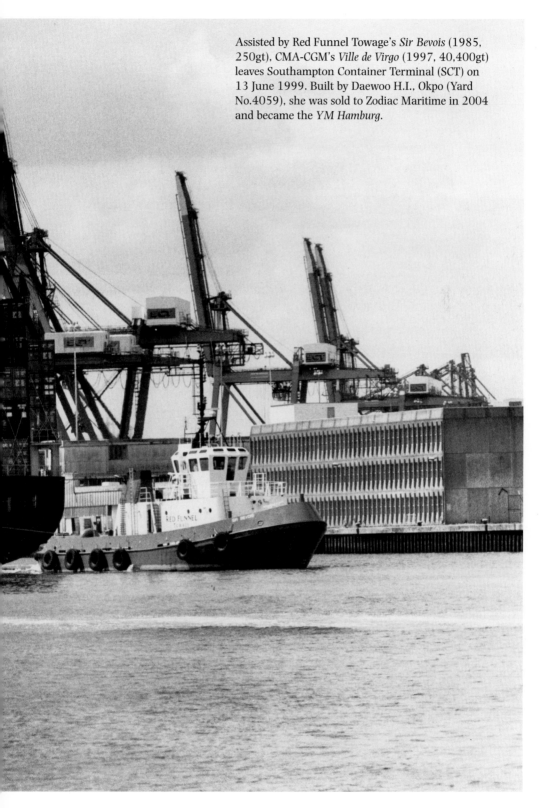

Assisted by Red Funnel Towage's *Sir Bevois* (1985, 250gt), CMA-CGM's *Ville de Virgo* (1997, 40,400gt) leaves Southampton Container Terminal (SCT) on 13 June 1999. Built by Daewoo H.I., Okpo (Yard No.4059), she was sold to Zodiac Maritime in 2004 and became the *YM Hamburg*.

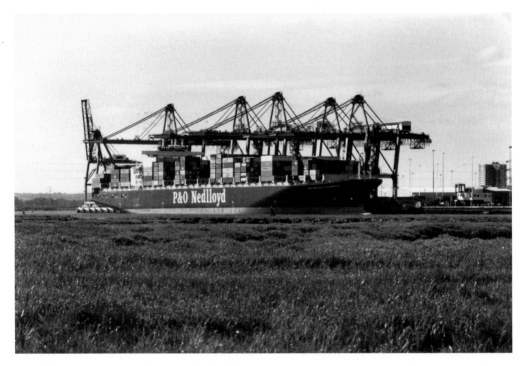

Above: Over the decade, the size of vessels using SCT increased dramatically. Here, a view across Berth 207 shows the *P&O Nedlloyd Southampton* (1998, 80,600grt) on 6 June 1999.

Opposite: A view of Falmouth Bay on 12 August 1993 shows Dammers Shipmanagement NV's reefer *Prince of Tides* (1993, 7,329grt) taking bunkers. According to the hull, she was employed at the time by Jamaica Producers.

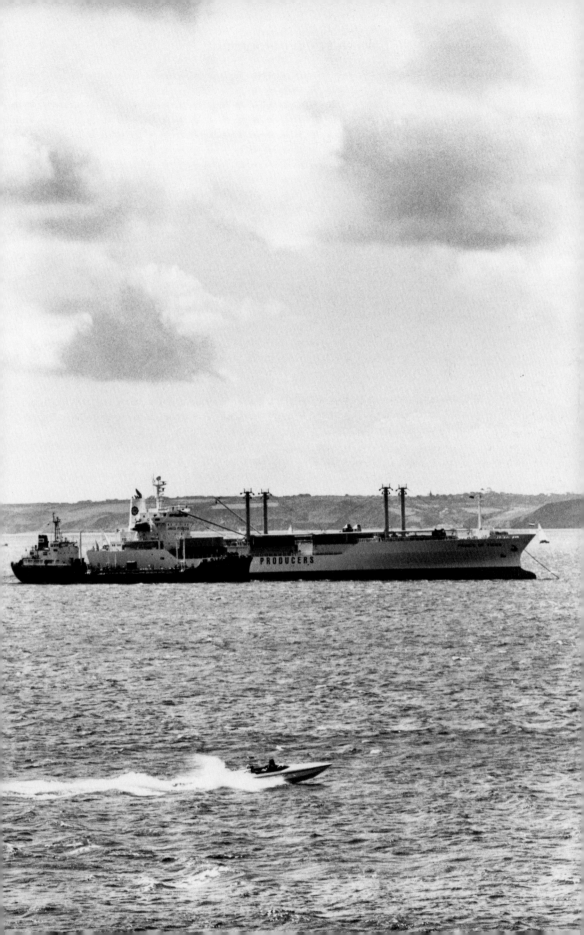

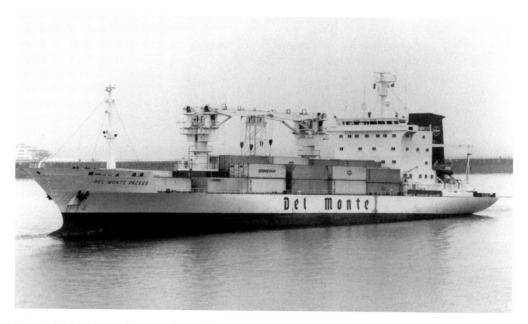

Seen in the harbour at Dover in 1999, the *Del Monte Packer* (1990, 8,945gt, IMO 8713598) had been built by AESA. Over the years, it has undergone several changes of identity. Chartered to Lauritzen, it was the *Sevilla Reefer*; it is now the *Pisang*.

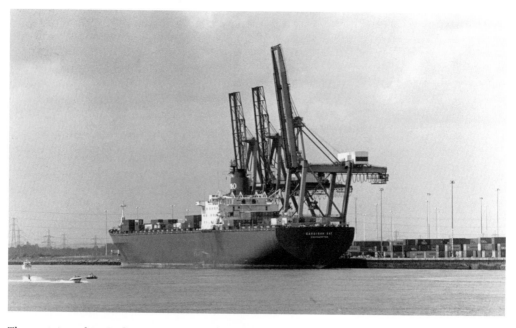

The container ship *Cardigan Bay* (1972, 58,889gt), Howaldtswerke, Deutsche Werft, Hamburg (Yard No.27), was one of six Third Generation 'Liverpool Bay' class of 2,961-TEU container ships designed by Ocean Fleets and operated by OCL on the UK–Far East run. OCL was acquired by P&O in 1986 and here the *Cardigan Bay* is seen at Berth 205 SCT in the early 1990s. She was scrapped at Alang in 1999.

Chapter 5

2000s

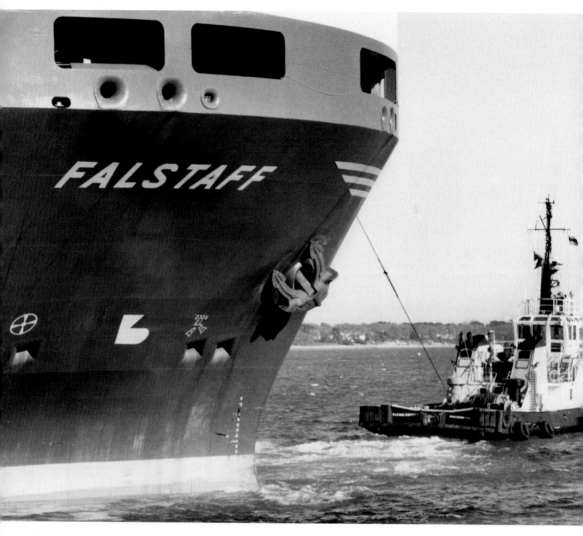

Above: Leaving the Itchen Quays, Southampton on 29 July 2001, Wallenius' Ro-Ro *Falstaff* (1985, 51,858grt) was assisted by the tug *Flying Osprey* (1976, 223gt). Built at Cuxhaven, the tug was the former *Johanna* (sold 1978) and the *Cornelie Wessels* (sold in 1986). In 2004, she went, as the *Boa Sand*, to Adstream Marine.

Opposite above: Moored at Berth 35/36 in the Eastern Docks at Southampton on 9 July 2002, Wilhelmsen Lines' *Taiko* (1988, 27,902gt) towers over the former Glasgow Corporation 'sludge' carrier *Shieldhall* (1955). The *Taiko* was built by Hyundai Shipbuilding and Heavy Industries Ltd, Ulsan, and launched as the *Barber Hector* for Ocean Transport and Trading plc, Liverpool. She was chartered to Wilhelmsen Lines in December 1989 and renamed *Taiko*.

The *Shieldhall* was built by Lobnitz & Co., Renfrew. For twenty-two years she served the citizens of Glasgow. In 1977, she was bought by the Southern Water Authority and continued her duties until 1985. She was bought by the Solent Steam Packet Ltd and is currently undergoing restoration.

Opposite below: Seatrade, Groningen had a long-term charter with Geest and the *Santa Lucia* (1999, 8,507gt) was one of the vessels involved. Built by Kitanahon Shipbuilding Co. (Hull 313), she is shown at the Windward Terminal at Southampton on 1 August 2000.

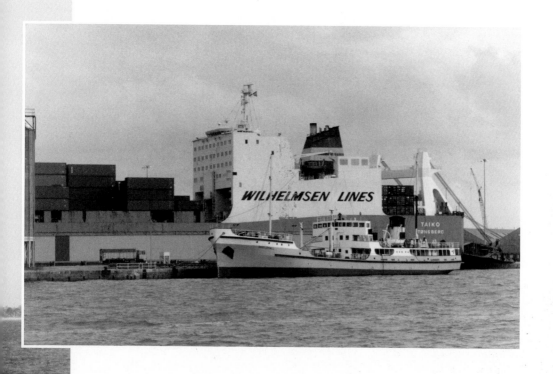

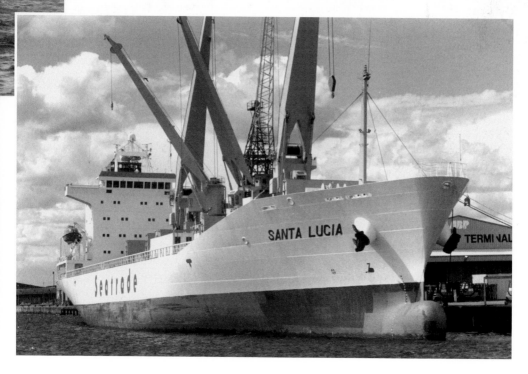

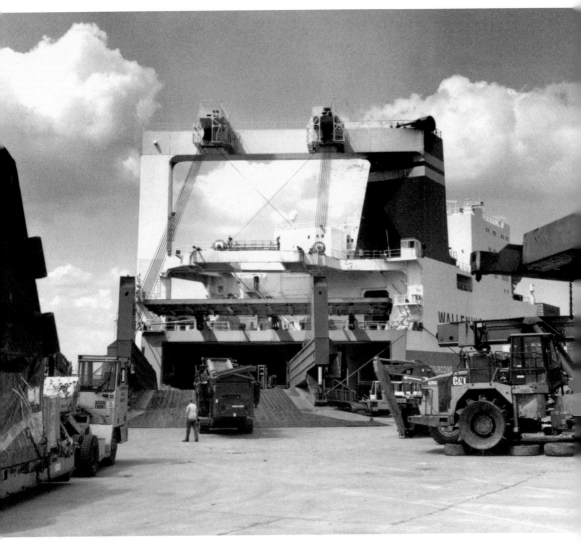

Wilh. Wilhelmsen's *Tourcoing* (1978, 22,434gt) was the third Wilhelmsen vessel to carry this name. Built by Mitsubishi H.I. Ltd in Kobe, she could carry 1,707 TEUs and had a quarter stern door and ramp used, as can be seen, to load anything that could be rolled or driven into the vessel. She is shown at Southampton on 20 October 2001.

Opposite above: Nedlloyd America (1991, 48,508gt) was a 3,604-TEU cellular container ship built by Ishikawajima-Harima H.I., Kure. Owned at the time by P&O Nedlloyd, she was seen at Berth 204, Southampton Container Terminal (SCT), on 9 November 2001. She was sold in April 2004 to 'America Star' SchiffahrtsGes.mbH, Rotterdam and carried the 'Blue Star' funnel colours.

Opposite below: P&O Nedlloyd Sydney (1991, 48,508gt, 3,604 TEUs) was built by Kvaerner Warnow Werft, Warnemunde (Yard No.011). She was seen at Berth 204 at SCT on 9 November 2001. A good-looking ship, she was acquired by A.P. Moller in 2006 and renamed *Maersk Pembroke*.

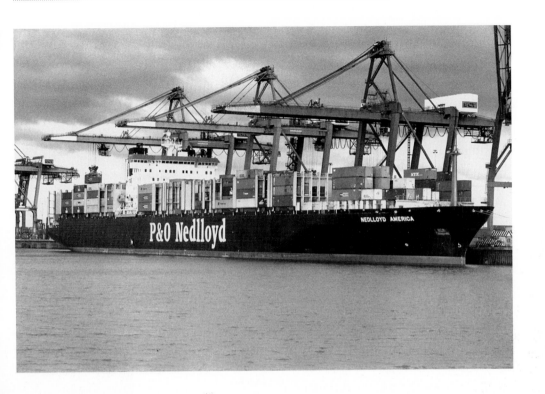

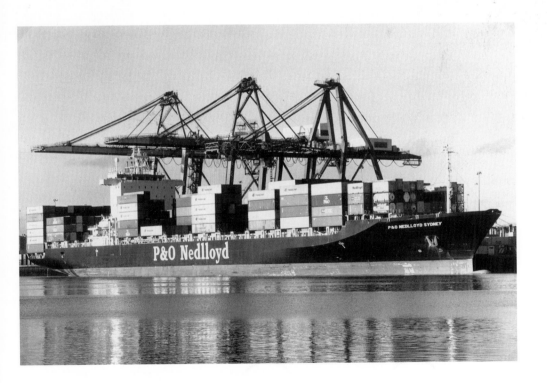

Wallenius-Wilhemsen's Ro-Ro/PCTC (pure car and truck carrier) *Falstaff* (1985, 51,858grt) was leaving the Itchen Quays at Southampton on the afternoon of 8 October 2000. She is now used on the company's China Express Service carrying not only cars and trucks but buses and high and heavy loads, including construction and agricultural and power-generation equipment (any cargo between 100 and 200t that can be wheeled or dragged over the stern ramp).

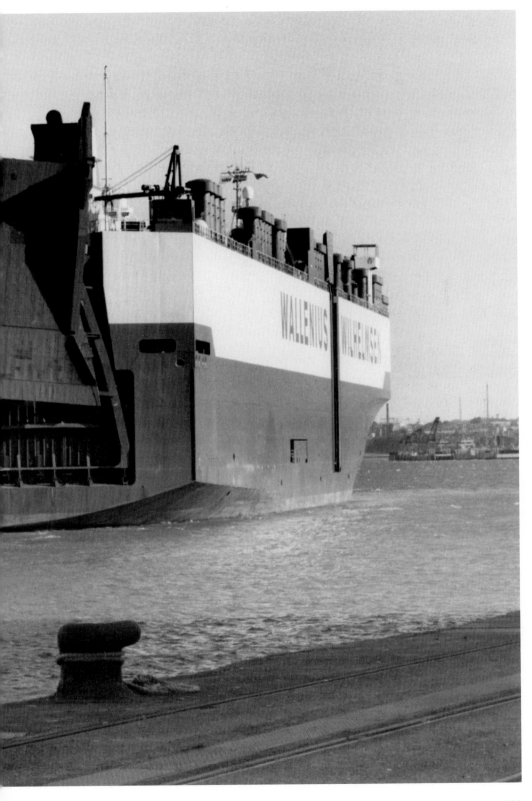

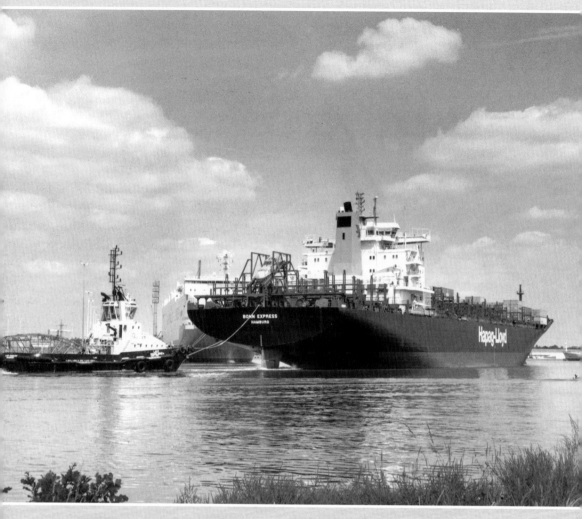

Hapag-Lloyd's *Bonn Express* (1989, 35,919grt), in immaculate condition, is seen leaving SCT on 14 July 2002. Built by Howatdtswerke-Deutsche Werft, Kiel (Yard No.235), she had a capacity of 2,803 TEUs.

A stiff breeze ruffled the water as the *Mogami Reefer* (1999, 8,077dwt) left Southampton's Western Docks. Built by Kyokuyo Zosen, the Panamanian-flagged vessel was a sister to the *Chikuma Reefer* and the *Nagato Reefer*.

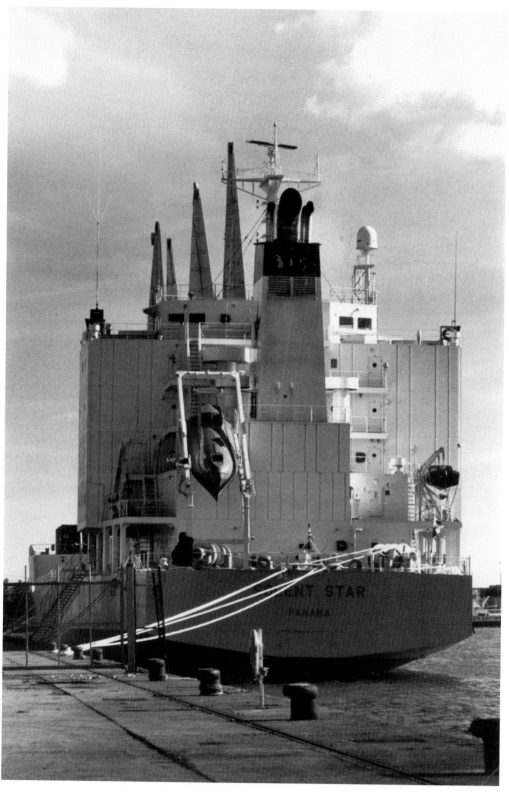

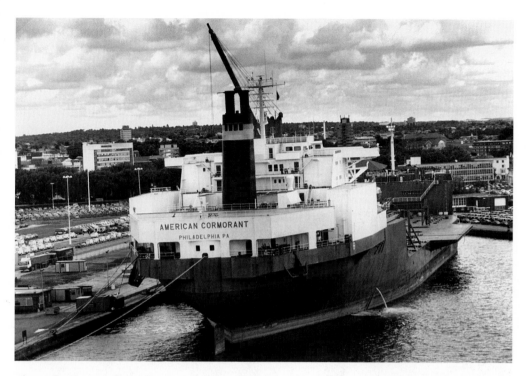

Above: The 'float on/float off' vessel *American Cormorant* was part of the US Military Sealift Command. Originally a conventional oil tanker (*Colibris*, built by Eriksbergs, Gothenburg), she was converted in 1982 to a semi-submersible, heavy-lift ship (the *Ferncarrier*). Cormorant Shipbuilding acquired her in 1985 and she was operated on time-charter to the US Army.

Opposite: The Panama-registered *Solent Star* (2001, 9,709dwt) was at the Windward Terminal, Southampton, on 25 February 2001, shortly after her completion. Geest Line, at the time, employed a fleet of five vessels which left the south coast every Wednesday and served St Lucia, St Vincent, Martinique, Barbados, Grenada and Antigua.

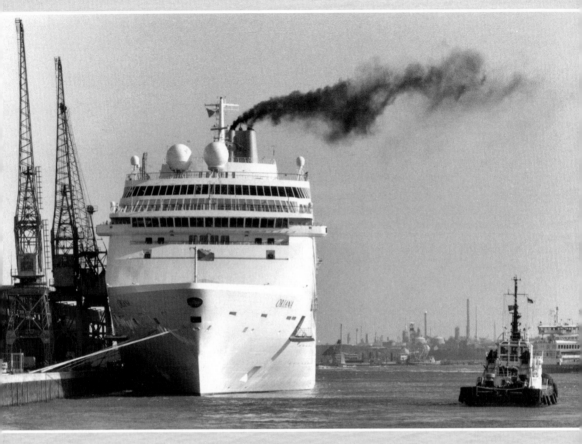

P&O's *Oriana* (1995, 69,153gt) was built by Jos. L. Meyer, Papenberg (Hull No.636). She was about to leave the Queen Elizabeth II terminal at Southampton on 9 July 2000, under the supervision of Adstream Marine's *Flying Osprey* (1976, 243gt).

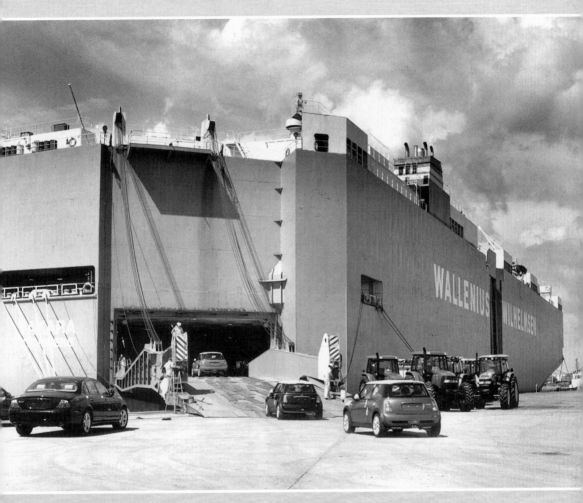

Mini Coopers were being driven via the stern quarter ramp onto the Wilhelmsen's PCTC (pure car and truck carrier) *Takara* (1986, 48,457gt) moored at Berth 43 at Southampton. On the quay, awaiting loading, are a Jaguar car and several tractors.

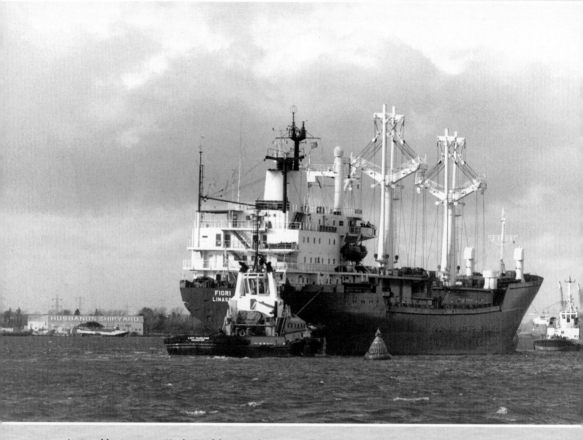

Assisted by two tugs (*Lady Madeleine* at the stern), the Cyprus-registered *Fiori* passed to the port side of Pier Head Buoy 2 as she negotiated the approaches to Southampton's Western Docks on 10 December 2000. A product of Neptun-werft, Rostock, the *Fiori* was a Neptun-421 multi-purpose vessel.

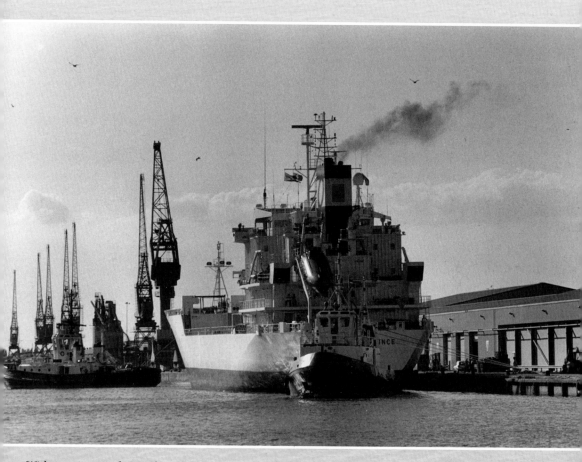

With tugs in attendance, the refrigerated vessel *Crystal Prince* was leaving Berth 102 at Southampton on 26 July 2001. At the time, she was in the ownership of Cool Carriers (AB). She is now named *Green Costa Rica*.

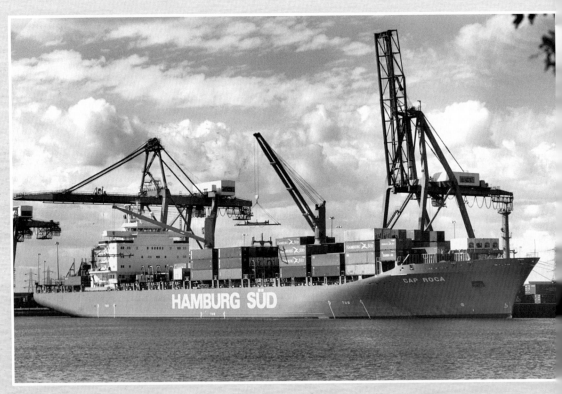

A further example of Hamburg-Süd's striking ships, the *Cap Roca* (1990, 35,303gt) was at Berth 204, Southampton Container Terminal, on 1 August 2000. Built by Hudong Zhonghua Shipyard, Shanghai (Hull 1178), she has a nominal capacity of 2,640 TEUs + 515 TEUs for reefer containers.

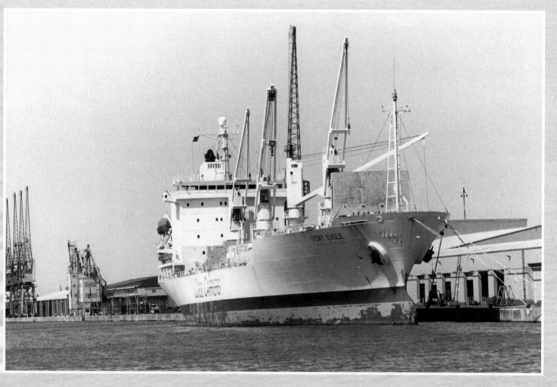

The refrigerated vessel *Ivory Eagle* (1992, 10,402gt) is seen at Berth 102 at Southampton in 2001. At the time, she was operated by Cool Carriers and owned by NYK Cool AB (a Swedish operator of reefer ships). As Hull No.865, she was built by Shikoku Dockyard, Takamatsu.

Grimaldi Lines' car/container carrier *Grande Brasile* (1999, 56,642grt) is shown at Berth 202 at Southampton on 10 September 2000. Built by Fincantieri (Hull 6055), she had a capacity for 1,321 TEUs and up to 3,515 cars. At the time, she was employed on the Northern and South America Express Service, linking Northern European ports with Casablanca, Dakar, Conakry, Rio de Janeiro and Santos.

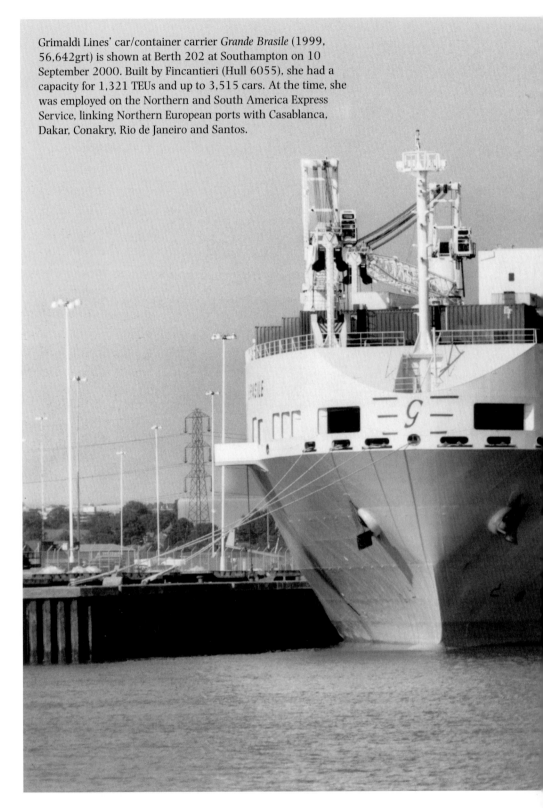

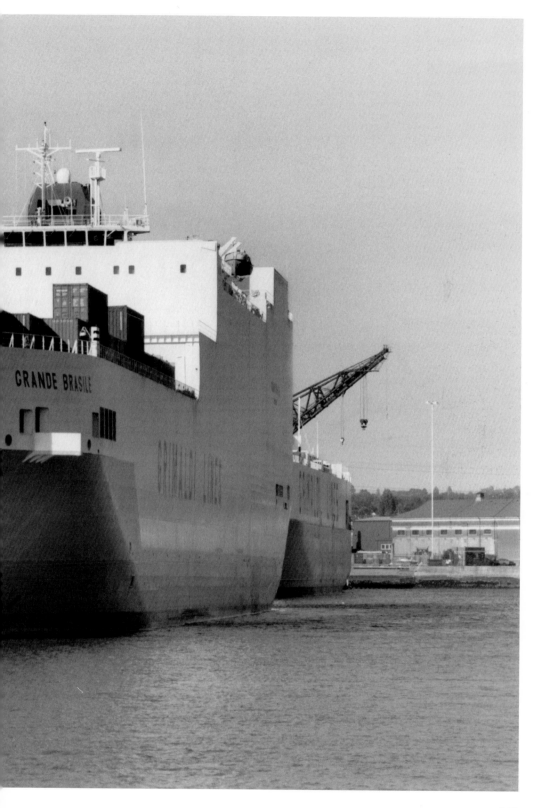

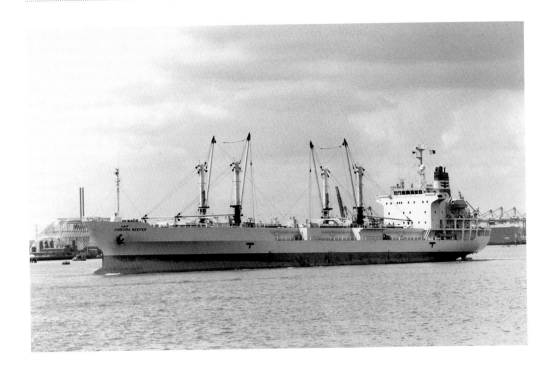

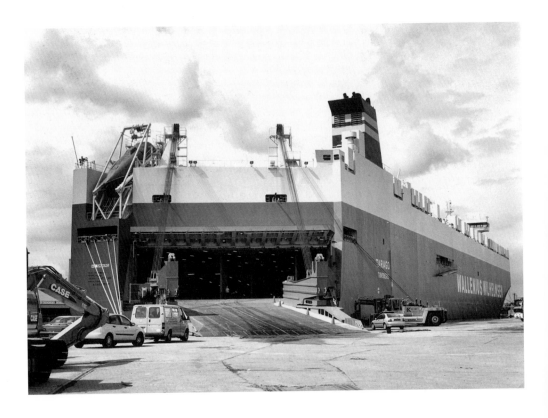

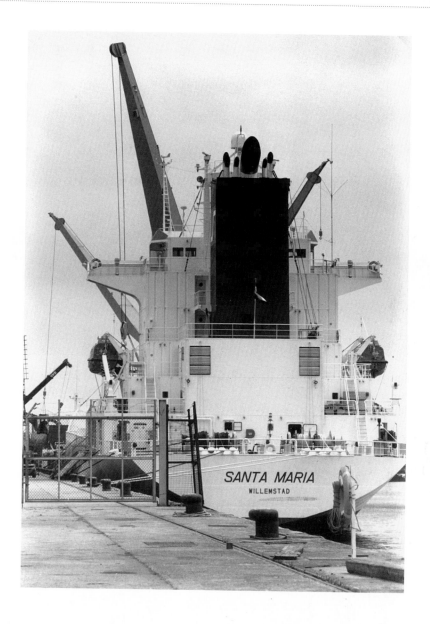

Above: The reefer ship *Santa Maria* (1999, 8,507gt) was built by Kitanihon Shipbuilding Co., Hachinoe (Hull 323) for Seatrade NV, Willemstad, Netherlands Antilles. She was chartered to Geest Bananas UK when seen at Berth 102, Southampton, on 23 July 2000.

Opposite above: The Panama-registered refrigerated cargo carrier *Chikuma Reefer* (1998, 7,367gt), owned by M.H. Maritima SA, is seen leaving Southampton's Western Docks. She had brought fruit from Sta. Cruz de Tenerife.

Opposite below: The *Tarago* (2000, 67,140gt) is one of Wilhelmsen Lines' Mk IV Ro-Ro ships. With eight decks, four of which are hoistable, they are suited to heavy-lift cargoes (power generators, agricultural and construction equipment). She was seen at Berth 43 at Southampton in July 2001.

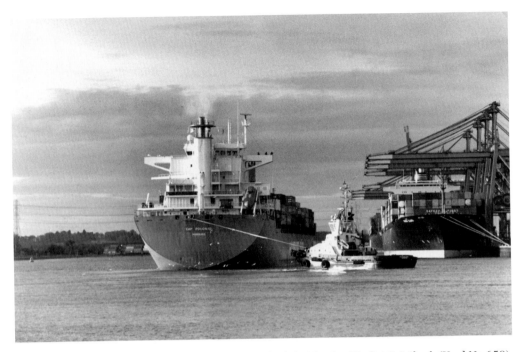

Hamburg-Süd's *Cap Polonio* (1990, 29,841grt) was built by Flender Werft AG, Lübeck (Yard No.650). The vessel has a container capacity of 2,022 TEUs and is shown here at Southampton Container Terminal being assisted into Berth 204 on 26 December 2001.

Opposite above: P&O's *Nedlloyd Drake* (2000, 66,526gt) was moored at Berth 206, Southampton Container Terminal, on the afternoon of 1 September 2001. She has a container capacity of 5,248 TEUs.

Opposite below: Wallenius-Wilhelmsen's Ro-Ro vessel *Toba* (1979, 22,008gt) was seen at Berth 40 at Southampton on 4 June 2002. Launched by Mitsubishi H.I., Kobe (Yard No.1094), she had a quarter stern ramp and a container capacity of 1,806 TEUs.

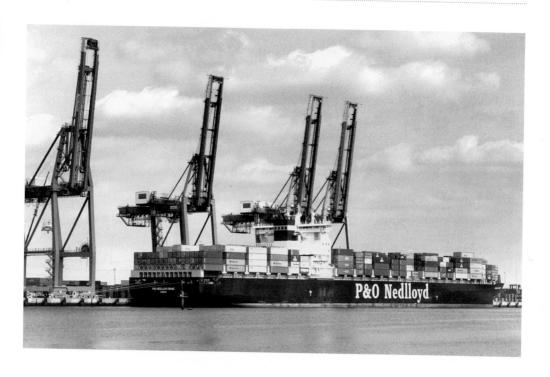

Built by Meyer Werft in Papenburg, the P&O Cruises ship *Aurora* (76,152gt) was launched on 18 April 2000. With a draught of 7.9m and a service speed of 24kt, she was leaving Southampton for Cadiz when photographed on 7 April 2001.

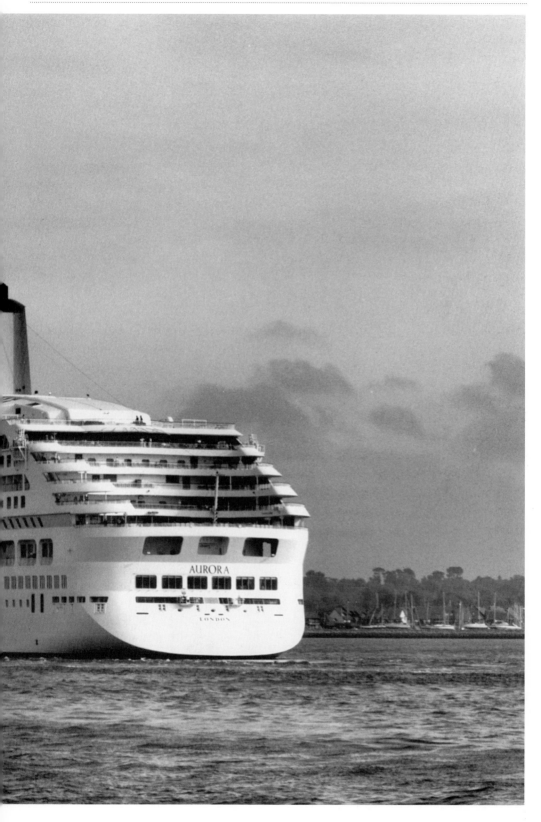

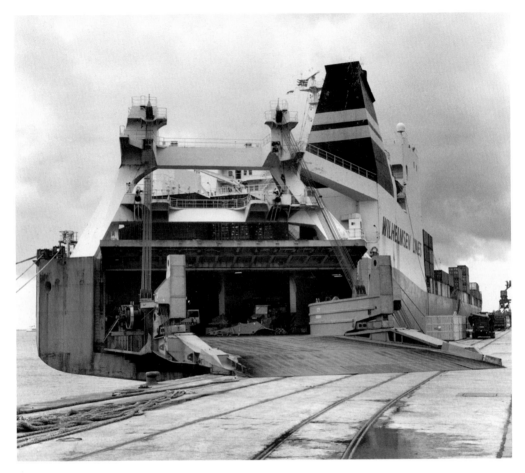

Wilhelmsen Lines' *Taiko* (1983) was launched by Hyundai H.I. Co. Ltd, Ulsan, as the *Barber Hector* for Ocean Transport and Trading plc, Liverpool. In November of that year, she was bought by Swedish Liners KB and renamed *Taiko*. She was at Berth 35/36 at Southampton on 9 July 2002.

Opposite above: Wallenius-Wilhelmsen's vehicle carrier *Taronga* (1996, 72,708gt) was built by Mitsubishi Heavy Industries. She was the fourth Wilh. Wilhelmsen ship to carry the name and was seen at Berth 40 at Southampton Docks on 23 June 2002.

Opposite below: Outward-bound from Southampton, The *MOL Integrity* (2001, 66,332gt, IMO 924 5017) was seen off Calshot. Built in Japan by Koyo Dockyard Co. Ltd, she was designed to carry hazardous cargoes.

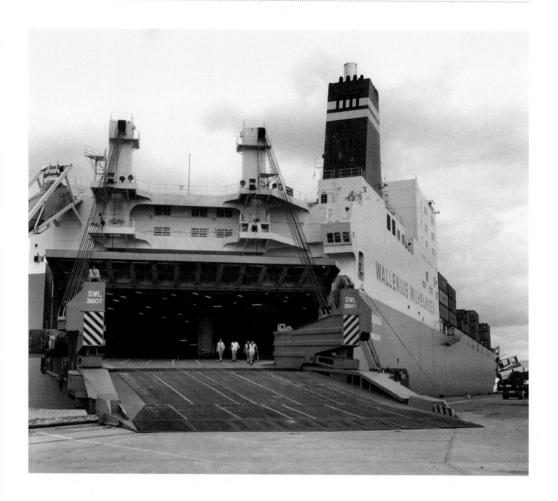

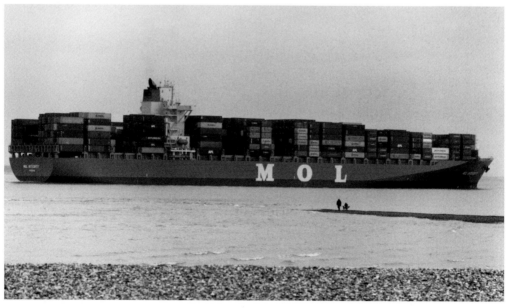

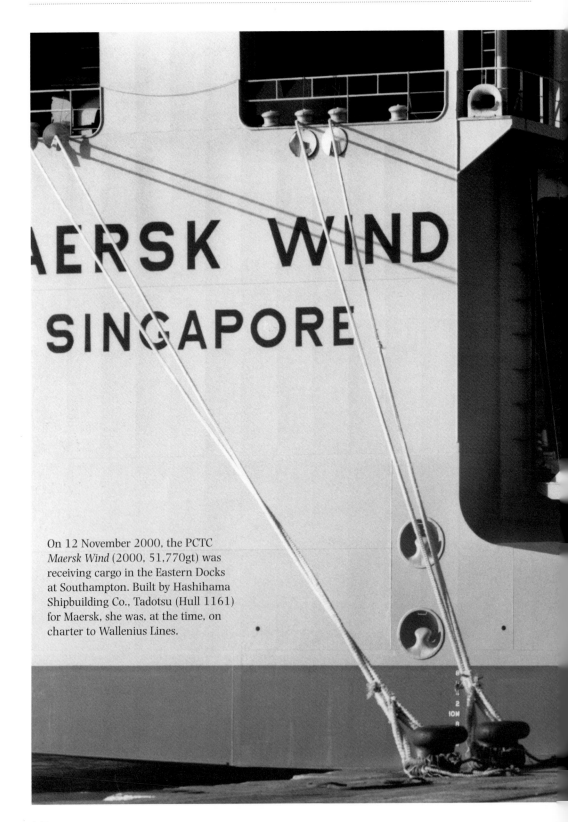

On 12 November 2000, the PCTC *Maersk Wind* (2000, 51,770gt) was receiving cargo in the Eastern Docks at Southampton. Built by Hashihama Shipbuilding Co., Tadotsu (Hull 1161) for Maersk, she was, at the time, on charter to Wallenius Lines.

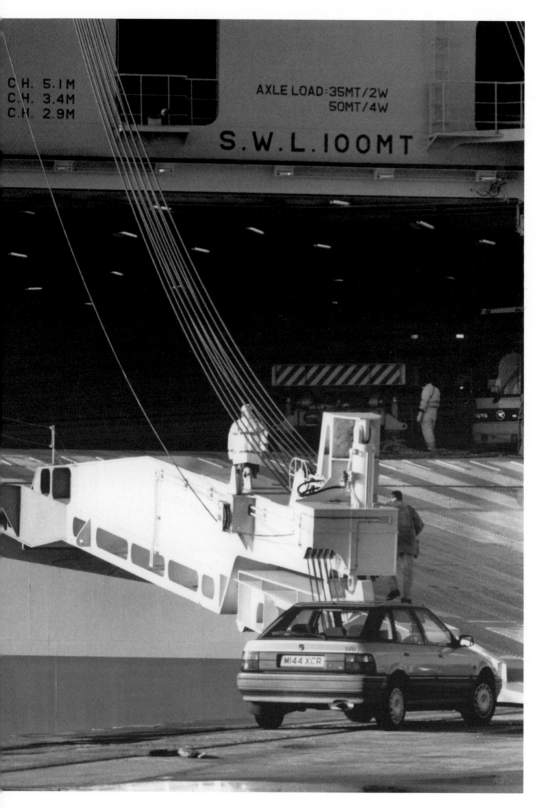

C.H. 5.1M
C.H. 3.4M
C.H. 2.9M

AXLE LOAD 35MT/2W
50MT/4W

S.W.L. 100MT

M144 XCR

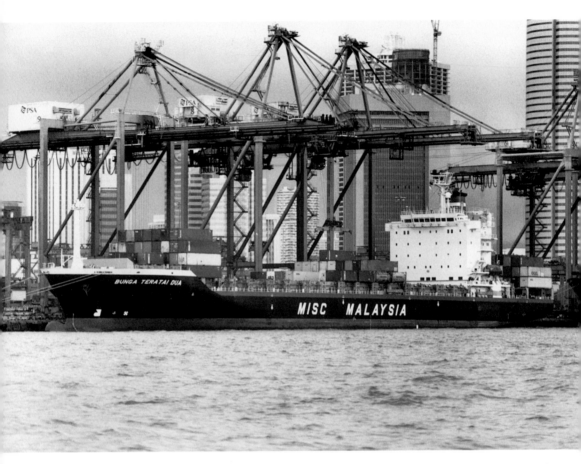

The Malaysian International Shipping Corporation (MISC) ship *Bunga Teratai Dua* (1998, 24,554t) was seen at Singapore on 12 June 2001. At the time, she was involved in a service to Ho Chi Minh City, Surabaya, Bangkok, Calcutta, Colombo, Brisbane and Sydney.

Opposite above: Alongside Berth 205, Southampton Container Terminal (SCT), was the Brazilian container ship *Alianca Brasil* (1994, 28,397gt), owned by Alianca Transportes Maritimos SA. Built at CCN-Brasil, the vessel had a capacity of 2,161 TEUs + 650 reefer TEUs. She was involved in a service involving Rotterdam, Tilbury, Antwerp, Le Havre, Sepitiba, Santos and Buenos Aires.

Opposite below: Zodiac Maritime's *Hyundai Independence* (1996, 64,054gt) had been built by Hyundai Ltd, South Korea (Yard No.913). On the still and sunny evening of 16 October 2001, she was alongside Berth 207 at SCT. Her route served Le Havre, Rotterdam, Hamburg, Southampton, Colombo, Singapore, Hong Kong, Hakata, Pusan, Kaohsiung and Port Kelang.

144

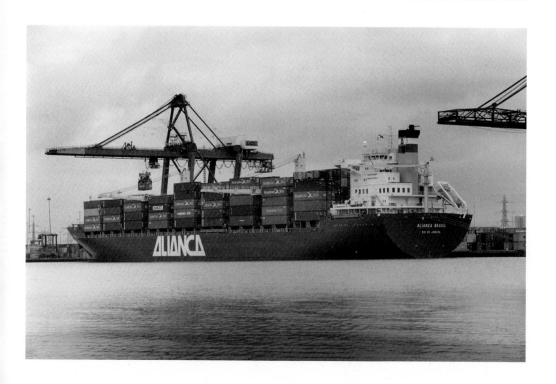

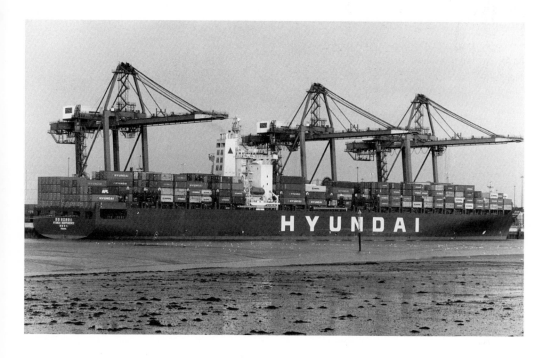

At Southampton Container Terminal on 4 November 2000 were Mitsui OSK's *Rhine* (1995, 62,905gt) and the *P&O Nedlloyd Kowloon* (1998, 80,942gt).

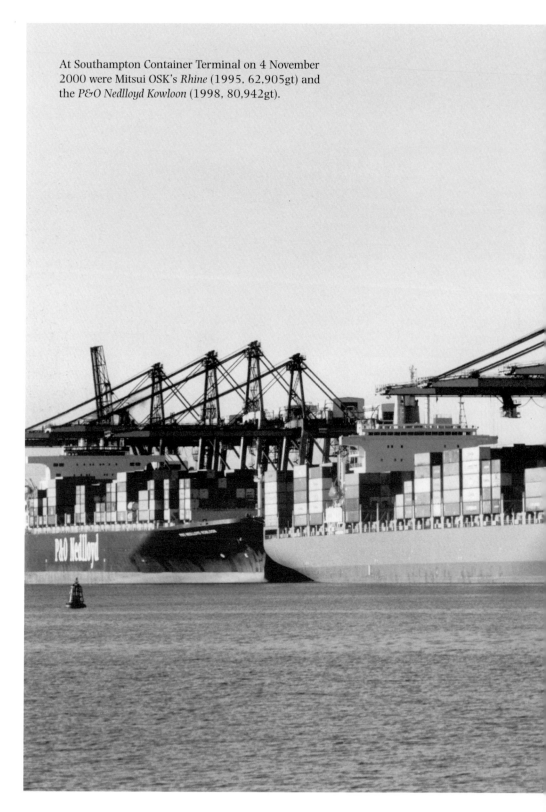

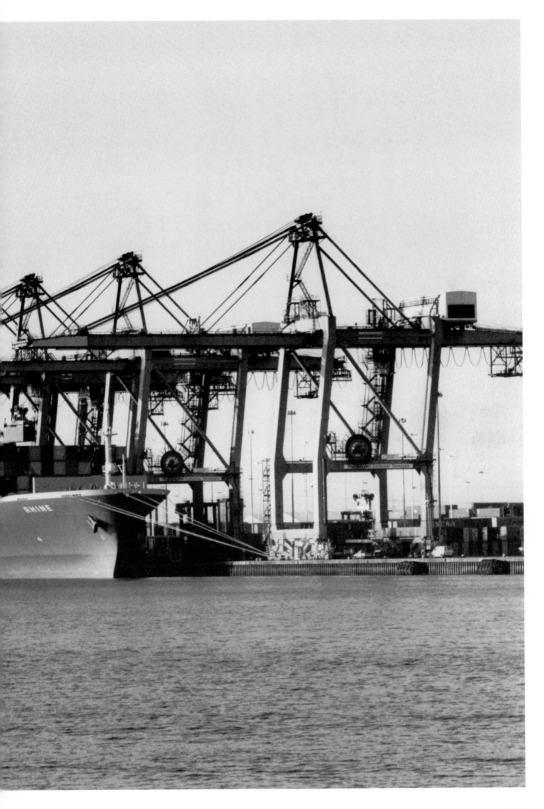

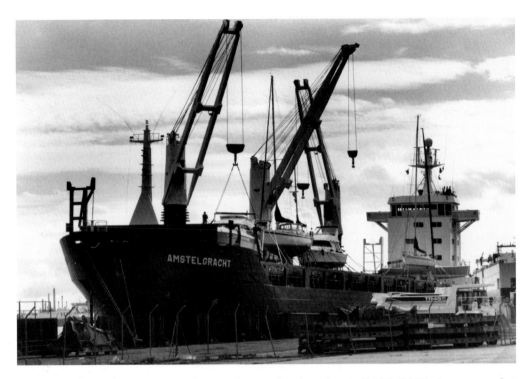

Spliethoff's Bevrachtingskantoor BV's general cargo ship *Amstelgracht* (1990, 7,950gt) was moored at No.30 Berth at Southampton on 8 September 2001. She was loading a wide range of cargo, including yachts and motor cruisers for the annual Southampton Boat Show.

Opposite: Built by Wärtsila, Helsinki (Yard No.464) for P&O Princess Cruises, the *Royal Princess* (1984, 44,348gt) was moored at the Mayflower Cruise Terminal, Southampton, on 23 June 2002. She retained the name until 2005 when she became *Artemis*. Another renaming took place in September 2009 when she was sold to Artania Shipping.

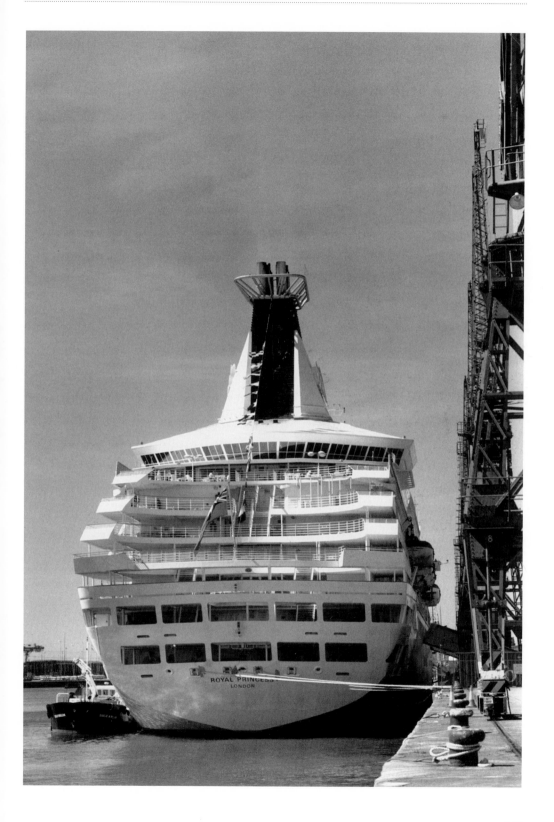

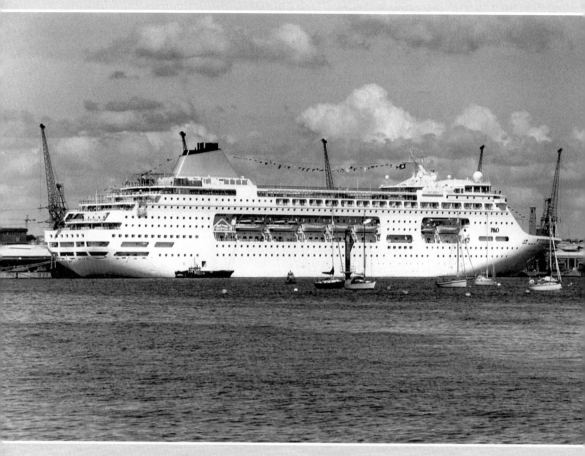

P&O's *Arcadia* (1989, 63524gt) was built at St Nazaire by Ch. de l'Atlantique and launched as *Sitmar Fair Majesty*. On 24 September 2000, she was moored at the Mayflower Cruise Terminal. A further renaming took place in 2003 when she became *Ocean Village*.

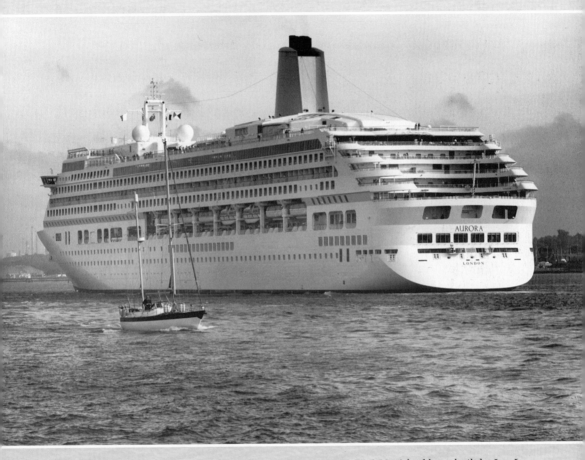

A mid-sized ship with an elegant tiered stern, P&O's *Aurora* (2000, 76,152gt) had been built by Jos. L. Meyer (Hull 640) at Papenburg. The *Aurora* has, unfortunately, perpetuated a seafaring myth in that the champagne bottle failed to smash at her naming ceremony and various problems have arisen in her subsequent career. She is seen here leaving Southampton for Cadiz.

Wallenius-Wilhelmsen's *Don Juan* (1995, 55,598gt) was built by Daewoo Heavy Industries, Okpo (Yard No.413). Moored at Berths 34/35 on the Itchen Quays in Southampton's Eastern Docks on 17 March 2002, some of the diverse cargo to be loaded can be seen on the dockside.

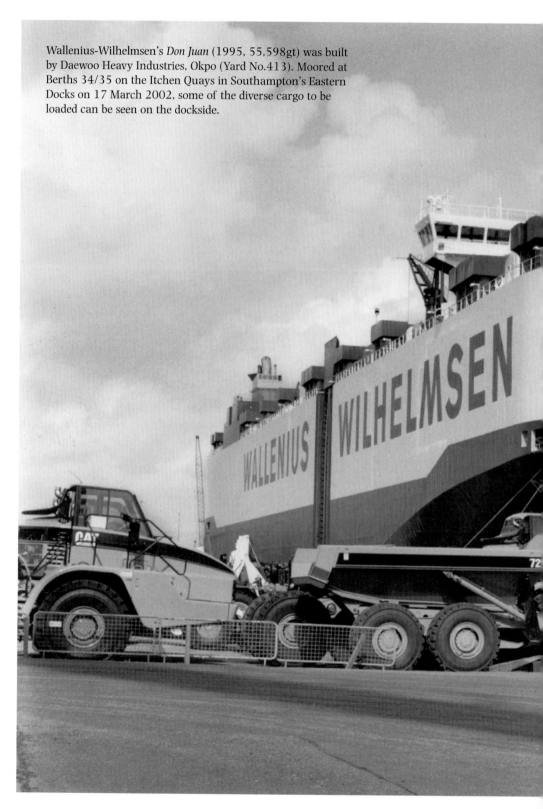

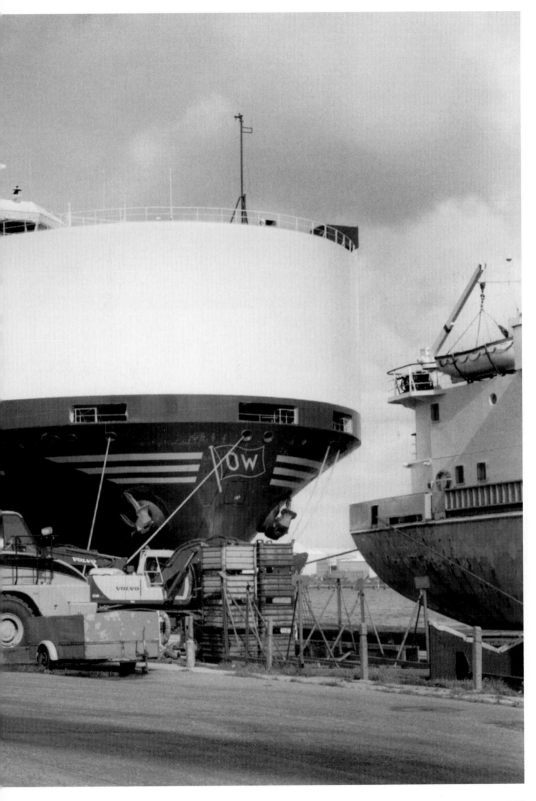

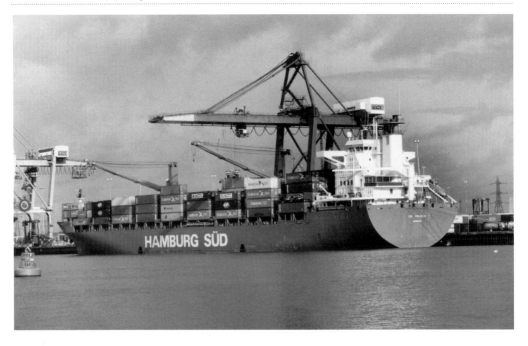

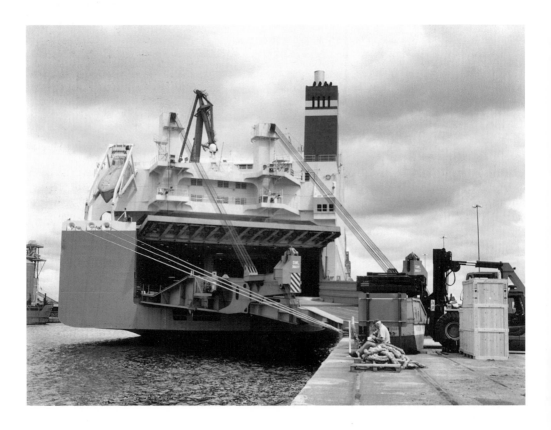

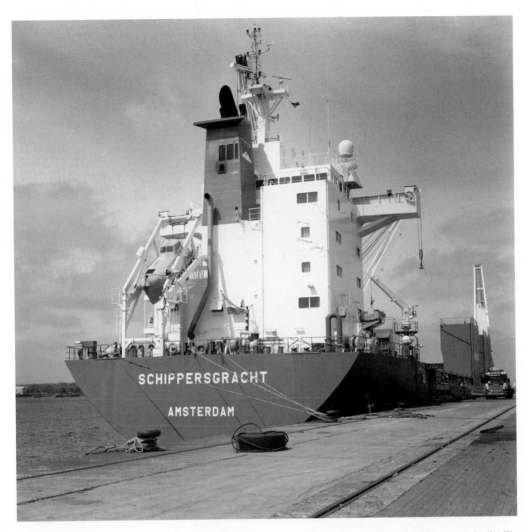

Loading for Montreal at Berth 102 in Southampton's Western Docks on 19 May 2002 was Spliethoff's Bevrachtingskantoor BV's *Schippersgracht* (2000, 16,641gt). She was the first in a series of ten very similar vessels and had been built by Mitsubishi H.I. at its Shimonoseki yard (Yard No.1060). Able to carry 1,100 TEUs and with five side-loaders, the members of the class could accept a wide range of dry cargoes including paper from the Baltic ports which was transported to North America.

Opposite above: Hamburg-Süd's *Cap Polonio* (1990, 34,000dwt) was moored at Berth 203 of Southampton Container Terminal on 4 October 2001. Built by Flender Werft AG, Lübeck (Yard No.650), she had a container capacity of 2,022 TEUs and was involved in the Europe–South America service.

Opposite below: A break for lunch during the loading of Wallenius-Wilhelmsen's *Taronga* (1996, 54,826gt) was being taken at Berth 43, Southampton Docks on 23 June 2002 prior to loading with, amongst other items, a cargo of Land Rovers. The *Taronga* (the name of the zoological garden in Sydney, NSW) had been built by Mitsubishi H.I., Nagasaki (Yard No.2109). Across the dock are some of the grain silos at Berth 47.

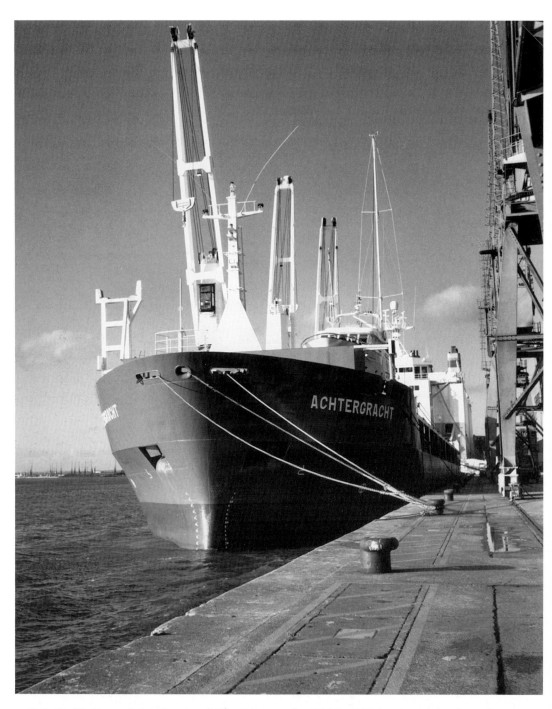

Spliethoff's Bevrachtingskantoor BV's *Achtergracht* (1990, 7,700grt) was the first of seven multi-purpose ships ordered by the Amsterdam company from Tille Scheepsbouw B.V., Kootsertille and Van der Giessen-de Noord, Krimpen. With a single box-shaped hold and three hatches, she could accommodate 678 TEUs (including 150 reefers). The holds, as can be seen, were served by three Hagglunds cranes (capacity 40t (SWL)) at 40m outreach. The *Achtergracht* is seen at Berth 102 on 12 November 2000.

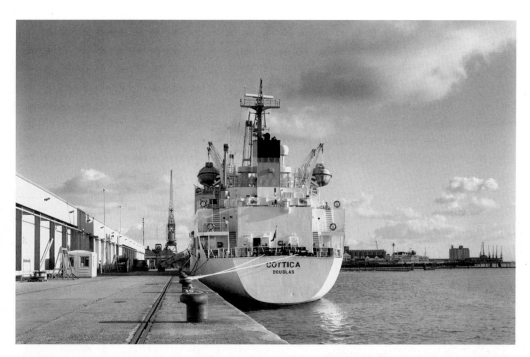

At the Windward Terminal, Southampton, on 4 November 2000 was the fruit carrier *Cottica* (1991, 4,660gt). Built at the Hayashikane Dockyard Co., Nagasaki (Yard No.967), she was one of three 4,000-ton 'banana boats' (the others being the *Coppename* and the *Jarikaba*) that traded between the UK and Suriname, Belize and Honduras and could carry seven passengers each.

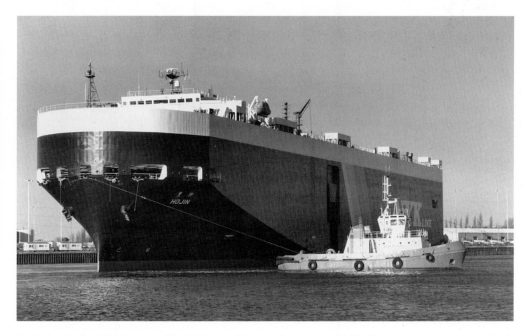

On 22 December 2001, assisted by Red Funnel Towage's tug *Hamtun* (1985, 250gt), NYK Lines' vehicle carrier *Hojin* (1990, 55,470grt) was moved from Berth 201 to Berth 40 at Southampton Docks.

At Berth 205, Southampton Container Terminal (SCT) on
28 October 2003, P&O Nedlloyd's *Nedlloyd Oceania* (1992,
48,508gt) was moored. Built by Ishikawajima Heavy
Industries (Yard No.3009), she flew the Netherlands flag
and could carry Hazard A cargoes. Over the years, SCT Ltd
has invested in new equipment. During 1997, three new
gantry cranes, with an out-reach of 50m and a standard
lift rating of 40 tonnes, were brought into use. Further, by
dredging, the approach channel between Fawley and Berth
207 has been deepened from 10.2 to 12.6m, allowing very
large, loaded container ships access to the port.

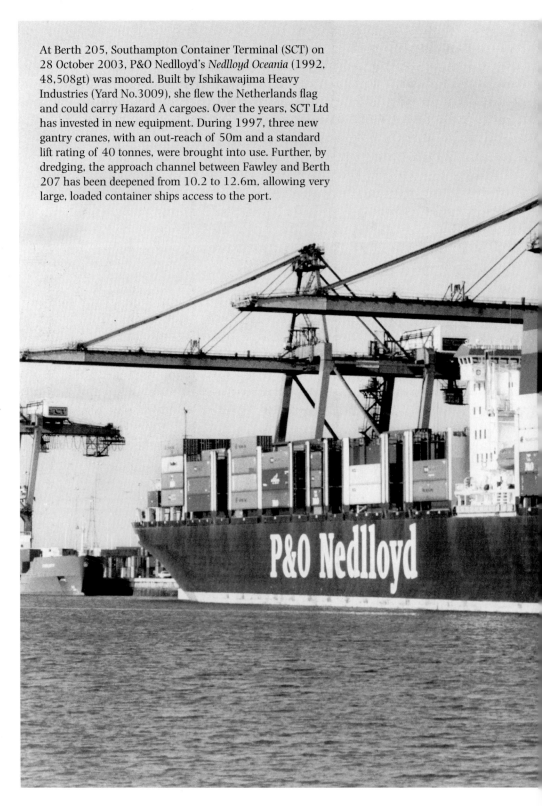

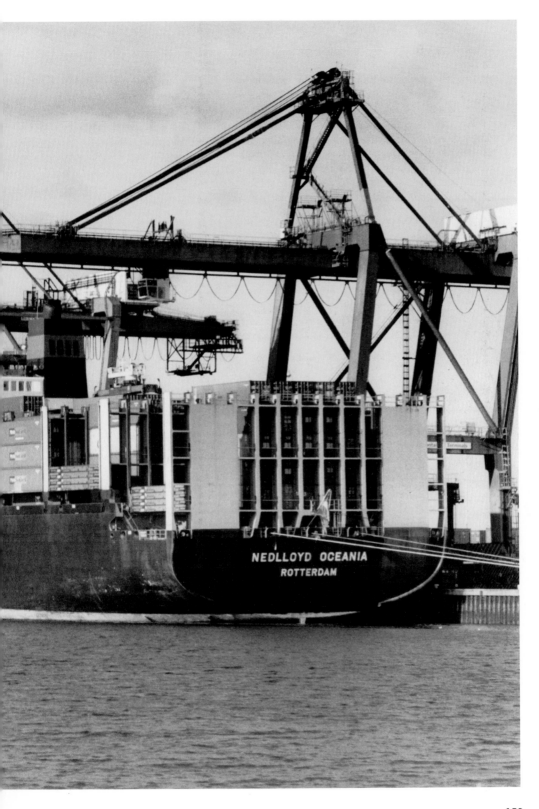

Other titles published by The History Press

British Diesel Locomotives
DAVID HUCKNALL

British Diesel Locomotives is a superb collection of black-and-white photographs, supported by David Hucknall's usual meticulously researched and well-written captions, that portrays important locomotive classes. From the Deltics, the Warships and the Westerns to the Class 50s and 47s and even including the humble but essential multiple units, this book will remind readers of a fascinating evolutionary period for Britain's railways.

978 0 7524 5142 8

Fiddler's Green: The Great Squandering 1921–2010
RICHARD WOODMAN

Plunged into depression after a brief post-war boom, the ships of the British Merchant Navy were called upon to repeat their sacrifice to the menace of German hostility. For over three years, the Merchant Navy maintained the supply of food and raw materials against appalling odds until victory ushered in a new age of peace and prosperity. However within a generation the Merchant Navy had all but vanished, its loss to the nation yet to be appreciated in one of the most fundamental changes to affect this country at the end of the millennium.

978 0 7524 4822 0

Building the Biggest: From Ironships to Cruise Liners
GEOFF LUNN

If the innovative engineers of the Victorian age guided the shipping industry from sail to steam, wood to iron and later to steel, then the twentieth-century invention of the computer took ship construction to entirely new concepts. Massive passenger vessels can now be built from keel to funnel in no more than two years. Construction techniques have changed beyond recognition, as have methods of ship design and, indeed, the very roles that these floating resorts are asked to play.

978 0 7524 5079 7

Great British Passenger Ships
WILLIAM MILLER

This illustrated history charts the heyday of the British passenger ship, those grand vessels that connected the continents, but also those far-off colonial outposts of the Empire. There were the great Cunarders, but also the likes of Booth Line to the exotic Amazon, Royal Mail to Rio and Buenos Aires and the iconic P&O to Sydney, Singapore and colonial Hong Kong. Including previously unpublished images with personal anecdotes from passengers and crew alike, William Miller takes the reader on a nostalgic voyage.

978 0 7524 5662 1

Visit our website and discover thousands of other History Press books.
www.thehistorypress.co.uk